British Passenger Liners

IN COLOUR

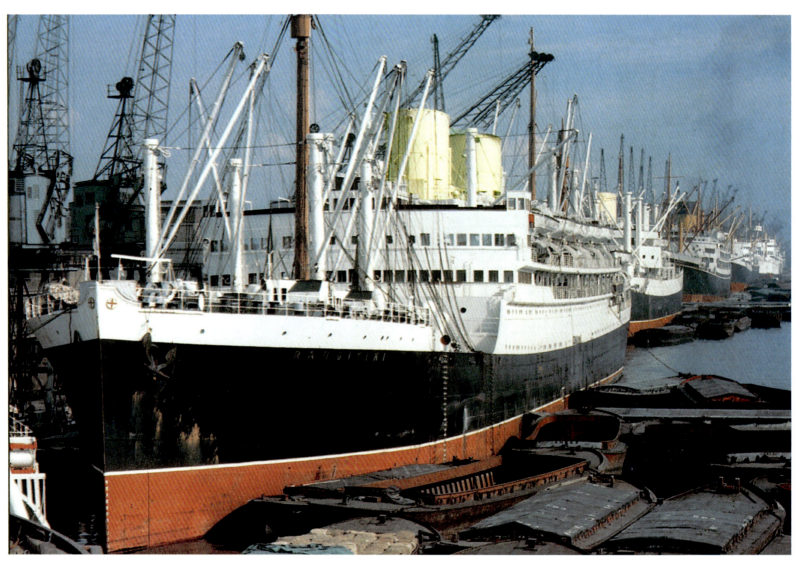
Arriving from New Zealand, the *Rangitiki* is seen on a busy day in the London Docks. (Mick Lindsay Collection)

British Passenger Liners

IN COLOUR

The 1950s, '60s and Beyond

WILLIAM H. MILLER

First published 2023

The History Press
97 St George's Place, Cheltenham,
Gloucestershire, GL50 3QB
www.thehistorypress.co.uk

© William H. Miller, 2023

The right of William H. Miller to be identified as the Author of this work has been asserted in accordance with the Copyright, Designs and Patents Act 1988.

All rights reserved. No part of this book may be reprinted or reproduced or utilised in any form or by any electronic, mechanical or other means, now known or hereafter invented, including photocopying and recording, or in any information storage or retrieval system, without the permission in writing from the Publishers.

British Library Cataloguing in Publication Data.
A catalogue record for this book is available from the British Library.

ISBN 978 1 80399 210 5

Typesetting and origination by The History Press
Printed in Turkey by Imak

This book is dedicated with respect and affection to all the ships, to their architects and builders, and to the men and women who have taken them around the world.

COVER: *Front:* After the Second World War, the Royal Mail liner *Asturias* was restored, but used for trooping and carrying migrants. She is seen arriving at Melbourne. (Author's collection) *Back:* Queen Elizabeth in New York, January 2011. (Cunard Line)

BELOW: Southampton Docks in the 1950s: the freighter *Brisbane Star*, the giant *Queen Elizabeth* and the *Athlone Castle* and *Carnarvon Castle* beyond. (Mick Lindsay collection)

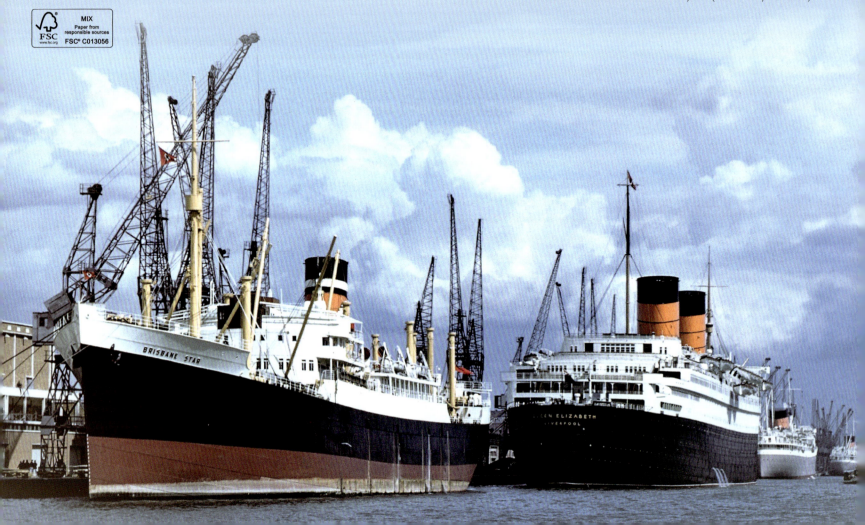

Foreword

I attended Bill Miller's wonderful lectures on the *Queen Mary 2*. The Cunard flagship was then crossing westbound – from Southampton to New York – and the date was March 2022. It was then almost sixty years ago when my family and I made a two-week voyage from Southampton to the Mediterranean in the *Chusan*. That was my very first voyage.

My family was hooked – we just loved cruising! My father quickly gave up the British seaside or summer trips up to Scotland – P&O was the way to go! There were so many memorable points: English breakfasts, elevenses (tea at 11 a.m. coupled with a plain biscuit), naps for an hour each afternoon, lovely dinners and afterwards very nice shows or cabaret artists. It was all British passengers back then – and people from every station and status of life, from proper old colonials and retired corporate types to budgeted retirees, school mistresses and even seaside landladies. We'd have lots of time on deck, seated around the pool or in the shade of the boat and promenade decks. P&O had those seaside chairs with the sling canvas seating. I also seem to recall afternoon tea being held in the ship's restaurant. The captains and officers were all British and the stewards and waiters a mix of British and Indian. Some had been with P&O for years, even decades, and for some of the Indians it was a long family affair – their grandfather and fathers had served aboard P&O ships.

Happily, I have been on over fifty voyages since then – most of them out of British ports. It has all changed, but it is still magical to me. Being seated on deck, afternoon tea and visiting faraway places – those components have remained the same – although many earlier ships and even shipping companies themselves are now gone. But thanks to Bill, his lectures and his books, including this latest title, these bygone ships live on. Myself, I am already looking forward to my next voyage.

Esme Prestwick
London, England

Acknowledgements

Much like designing and then constructing these great ships, it requires many hands – in fact, a full crew – to create a book. Organising this book has included many friends and acquaintances, all of whom deserve an appreciative mention. My sincere appreciation to all – and any omissions are regretted.

First of all, thanks to Amy Rigg and the staff at the very fine The History Press for taking on this project. And very special thanks to Esme Prestwick for her generous foreword and to Michael Hadgis, Anthony La Forgia, the late Mick Lindsay and David Williams for their exceptional contribution and assistance, particularly with photographs.

Further thanks to the late Hans Andresen, the late Frank Andrews, the late Bill Barber, Robert Bishop, Philippe Brebant, Stephen Card, Luis Miguel Correia, the late Bob Cummins, Allan Davidson, Anthony Davis, John Dimmock, Geoff Edwards, Terry Foskett, Hilary Gordon, Dr Nico Guns, Captain Aseem Hashmi, the late John Havers, Stanley Howard, David Hutchings, the late Marvin Jensen, Peter Knego, Graham Lees, Robert Lloyd, Captain James McNamara, the late Vincent Messina, John Moyer, Tim Noble, Michael Stephen Peters, Peter Plowman, Audrey Roberts, Michael Robertson, Peter Rushton, Cyril Smith, Dave Smith, Kay Stephens, Geoff Stewart, Rich Turnwald, Kenneth Wrightman and Captain Justin Zizes.

Companies and organisations that have assisted include Crystal Cruises, Cunard Line, Discovery Cruises, Fred. Olsen Cruise Lines, Ocean Liner Society, P&O Cruises, P&O–Orient Lines, Saga Cruises, St Helena Shipping Company, Silversea Cruises, Steamship Historical Society of America, Union-Castle Line, Viking Ocean Cruises and World Ship Society, Port of New York Branch.

Introduction

Happy anniversary! Cunard had organised a dinner cruise on the glass-roofed *Bateaux*, departing from the famed Chelsea Piers, from Pier 61 at the foot West 21st Street and the Hudson River. The occasion was to honour a famous lady: May 2014 was, after all, the tenth anniversary of the *Queen Mary 2*, the most famous liner afloat and the biggest Atlantic ocean liner of all time. Sailing from Pier 61 is, in fact, a link to liner history: up until the 1930s, some of the grandest liners ever – fabled ships such as the *Olympic*, *Rex* and *Empress of Britain* – used the very same berth. The passenger list included Cunard as well as New York Harbor officialdom, press, travel writers and agents, and 'friends of the Line'. The drinks flowed, the food was glorious and a trio played some handpicked tunes, which of course included 'Happy Birthday'. Unfortunately, Mother Nature was not quite in a celebratory mood – there was rain, sometimes heavy rain, and fog. But even if the city skyline was murky and clouded, even mysterious at times, the effect was pure Hollywood. I could just about 'see' Fred and Ginger doing one of those Cole Porter songs while crossing on the Hoboken ferry.

Nearly a decade later, on a spring afternoon in 2022, I was joining the *Queen Mary 2* at her Southampton berth. Passengers were being processed and then boarding, luggage was being loaded and stores and provisions were fed into huge doorway openings along the ship's seemingly endless sides. Excitement filled the air – another voyage was soon to begin! But for a time, I thought back to bygone days and of the many earlier British passenger ships that had passed through this port. From these very docks, the likes of the *Andes* once departed for Rio and Buenos Aires, the *Windsor Castle* for Cape Town and Durban, and the *Oriana* for Melbourne and Sydney. And, of course, there were others, far smaller and possibly less well remembered: the *Golfito* heading off to the Caribbean, the *Aureol* casting off for West Africa and the *Chitral* bound for Hong Kong. All wonderful ships and wonderful memories.

Hopefully, this book is also a 'voyage' – a voyage of recollections of British passenger ships of the 1950s and '60s, with a review, a glorious link, of more contemporary British cruise ships.

Bill Miller
Secaucus, New Jersey
Autumn 2022

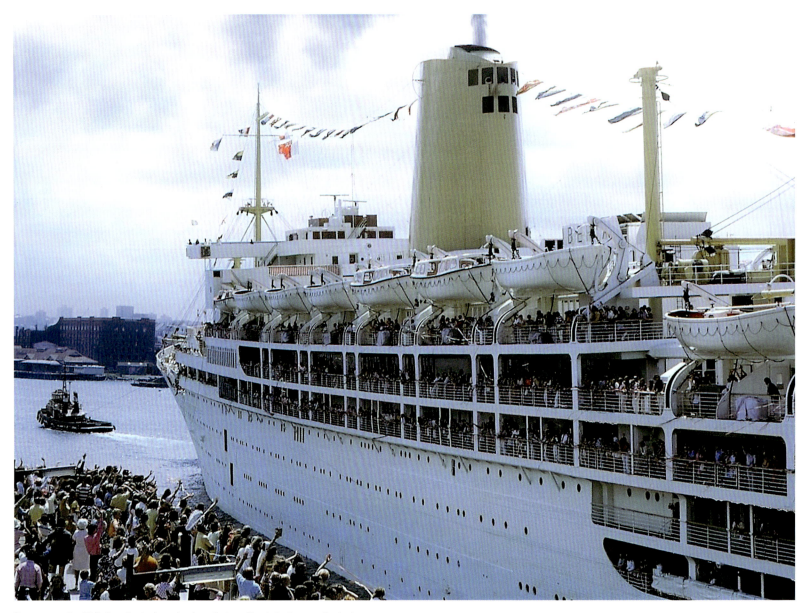
Bon voyage: the P&O liner *Iberia* departing from Sydney. (Frank Andrews collection)

PART I

Great Bygone British Passenger Ships

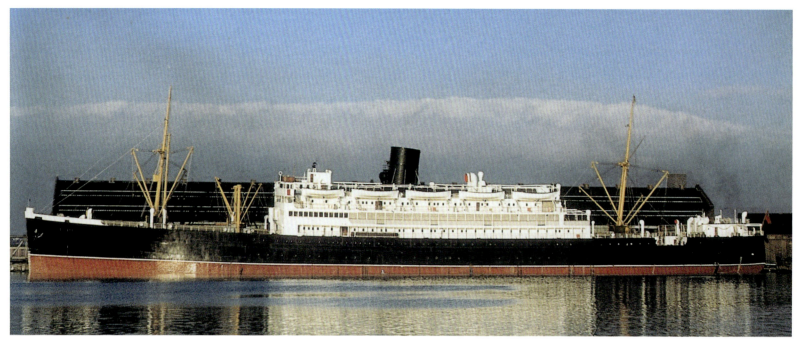

Anchor Line's 506ft-long *Cilicia* in the docks at Birkenhead. (Mick Lindsay collection)

Anchor Line

Caledonia, Cilicia and *Circassia*

This historic, Glasgow-based shipping company employed three passenger ships – the *Caledonia, Cilicia* and *Circassia* – that carried approximately 300 all-first-class passengers each. These 11,100grt vessels were routed between Liverpool, Gibraltar, Port Said, Aden, Karachi and Bombay (modern Mumbai). A crew member recalled, 'These ships were always immaculate. They were run like floating manor houses. Everything shined. The passengers sometimes included Indian maharajas and their entourages.'

Bibby Line

Derbyshire, Worcestershire, Warwickshire and *Leicestershire*

Remaining in business to this day, Bibby was best known for its Burma service – carrying passengers and cargo between Liverpool, Port Said, Aden, Colombo and Rangoon (modern Yangon). In the early 1960s, four combo ships were employed: the 115-passenger *Derbyshire* and *Worcestershire*, and then the 76-berth sisters *Leicestershire* and *Warwickshire*. Each of these ships was all-first class. 'We had the colonial administrators, civil servants and sometimes even the odd tourist,' recalled a Bibby officer.

Great Bygone British Passenger Ships 11

The *Derbyshire* used to have four masts before she was rebuilt after the Second World War. (Mick Lindsay collection)

The 8,922-ton *Leicestershire* entering the Gladstone Dock at Liverpool, with the *Reina del Pacifico* on the left. (Mick Lindsay collection)

Devonshire and Oxfordshire

The company also operated the troopship *Devonshire*, dating from 1939, and which was joined in 1957 by the newly built, 20,586-ton *Oxfordshire*. Both of these ships were chartered to the British Ministry of Transport and offered quarters in four classes: first, second, third and troop accommodation.

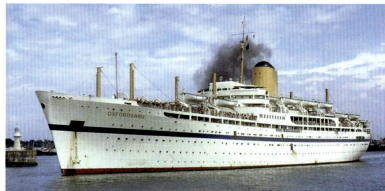

Peacetime trooping: the *Oxfordshire* could carry some 1,500 passengers in four classes. (David Williams collection)

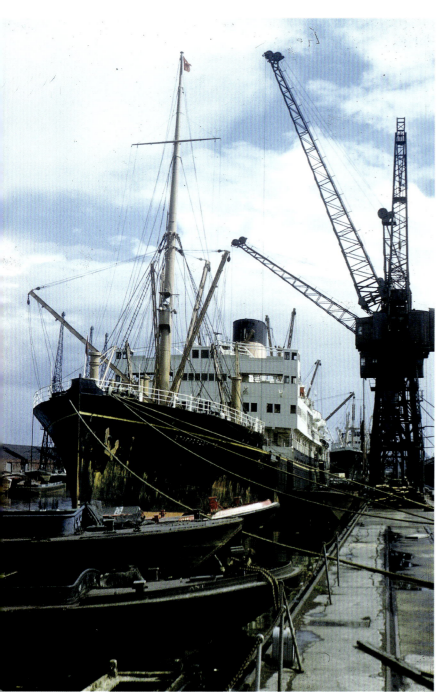

The 115-passenger *Staffordshire* loading in London Docks. (Mick Lindsay collection)

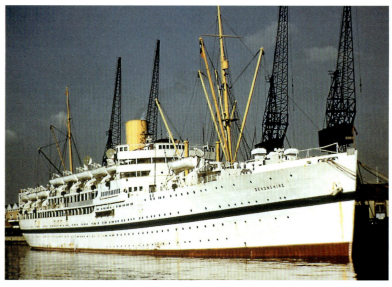

Dating from 1939, the *Devonshire* was one of four purposely built troopships. (Mick Lindsay collection)

Great Bygone British Passenger Ships 13

Blue Funnel Line

Hector, *Helenus*, *Jason* and *Ixion*

This British-flag company ran four thirty-passenger combination ships – *Hector*, *Helenus*, *Jason* and *Ixion* – on the UK–Australia run. The general itineraries were from Liverpool to Port Said, Aden, Fremantle, Melbourne and Sydney. A Blue Funnel staff member remembered, 'It was a very quiet life on board these ships. Long meals, quiet afternoons and, twice a week, records in the lounge for dancing.'

Peleus, *Pyrrhus*, *Patroclus* and *Perseus*

This well-known firm had a large fleet of cargo ships, some of which carried up to twelve passengers. But there were also eight combination ships, each carrying up to thirty one-class travellers. Four of them, the 10,100-ton sister ships *Peleus*, *Pyrrhus*, *Patroclus* and *Perseus*, were used on the Far East run. Ports of call varied but were usually Liverpool and Rotterdam and then onward to Port Said, Aden, Singapore, Hong Kong, Kobe and Yokohama. Other ports might be added based on cargo inducement and there was usually a call at Colombo on the homeward runs.

BELOW: With passengers and cargo, the 10,100-ton *Jason* is seen arriving off Sydney. (Peter Plowman collection)

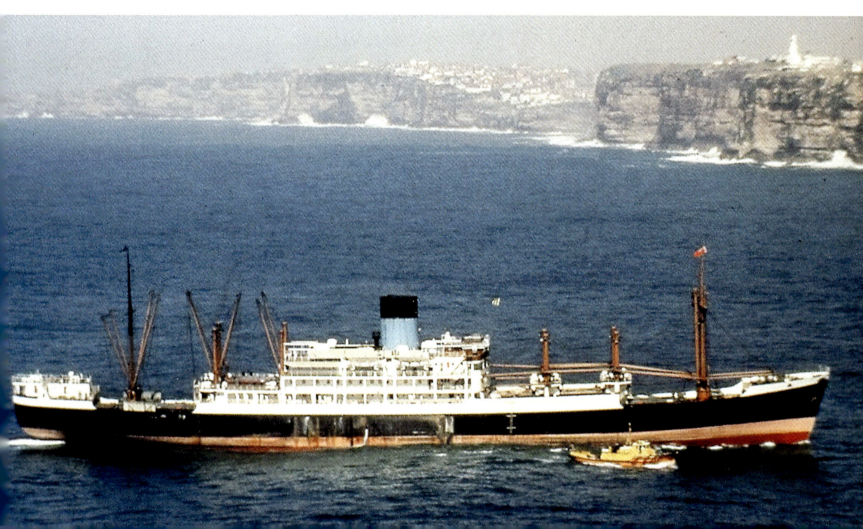

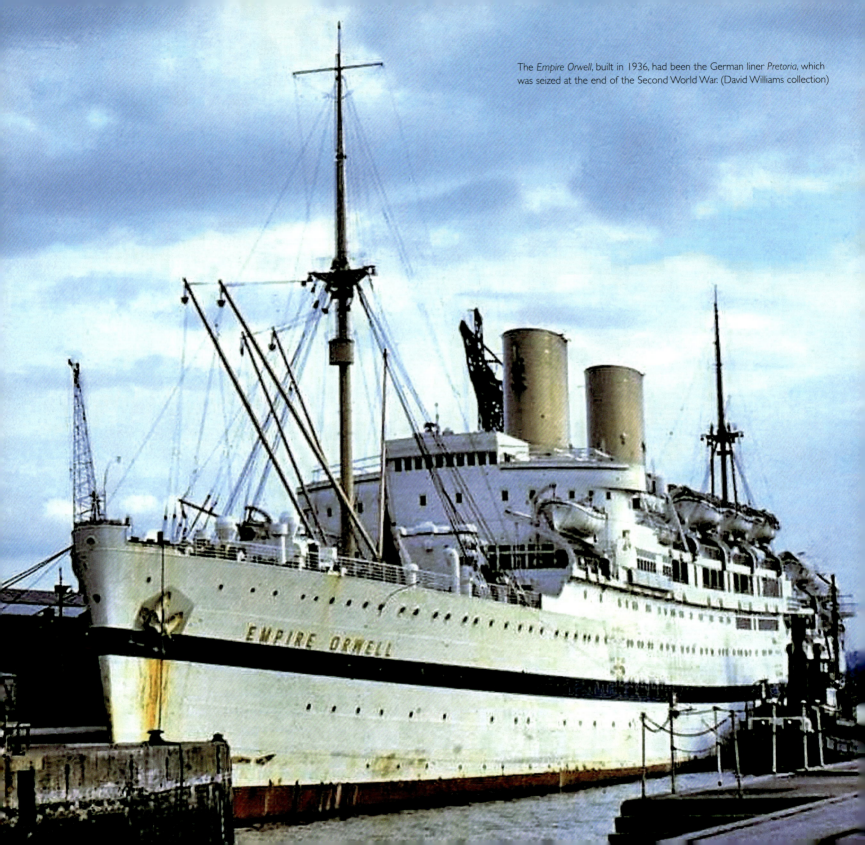

The *Empire Orwell*, built in 1936, had been the German liner *Pretoria*, which was seized at the end of the Second World War. (David Williams collection)

Charon and *Gorgon*

In eastern waters, Blue Funnel also operated two quite small passenger ships: the eighty-eight-passenger *Charon* and the seventy-two-passenger *Gorgon*. They were used in service between Fremantle, other western Australian ports and Singapore.

Gunung Djati (*Empire Orwell*)

In 1959, Blue Funnel added the 17,891-ton, 2,100-passenger *Gunung Djati*. A pilgrim ship used on the Indonesia–Jeddah run, she dated from 1936, having been the *Pretoria* of the German–Africa Line and later, after the Second World War, serving as the *Empire Doon* and mostly as the *Empire Orwell*.

Centaur

The 1963-built *Centaur* was the very last passenger ship created for Blue Funnel, but for a service far removed from the UK: between Singapore and Australia.

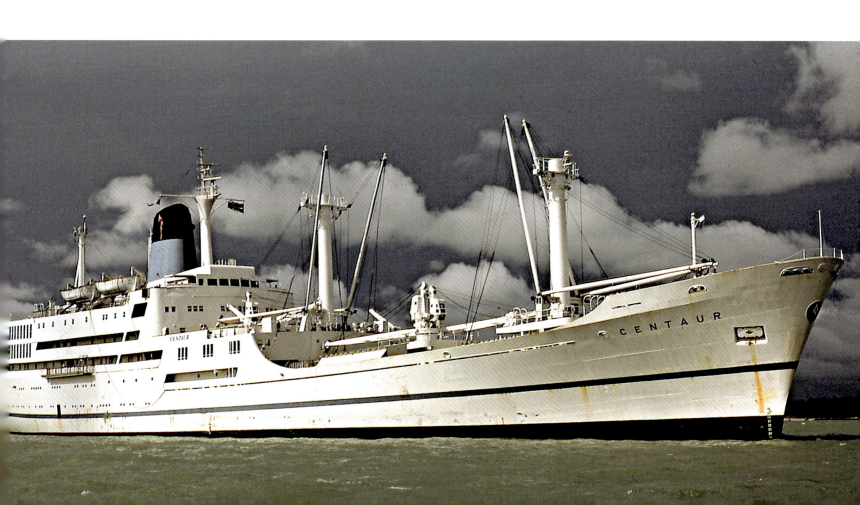

BELOW: The *Centaur* was Blue Funnel's last purposely built passenger ship. (Mick Lindsay collection)

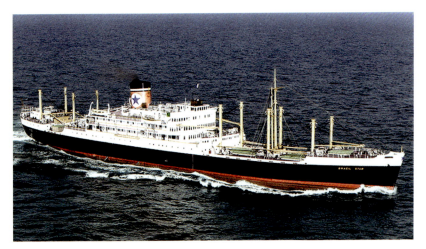

Blue Star Line

Argentina Star, *Brasil Star*, *Uruguay Star* and *Paraguay Star*
Iberia Star

This well-known British shipping company restored its South American passenger service after the Second World War with four combo liners that carried some fifty all-first-class passengers each. Named *Argentina Star*, *Brasil Star*, *Paraguay Star* and *Uruguay Star*, they were routed on two-to-three-week intervals from London to Lisbon, Madeira, Las Palmas, Tenerife, Recife, Salvador, Rio de Janeiro, Santos, Montevideo.

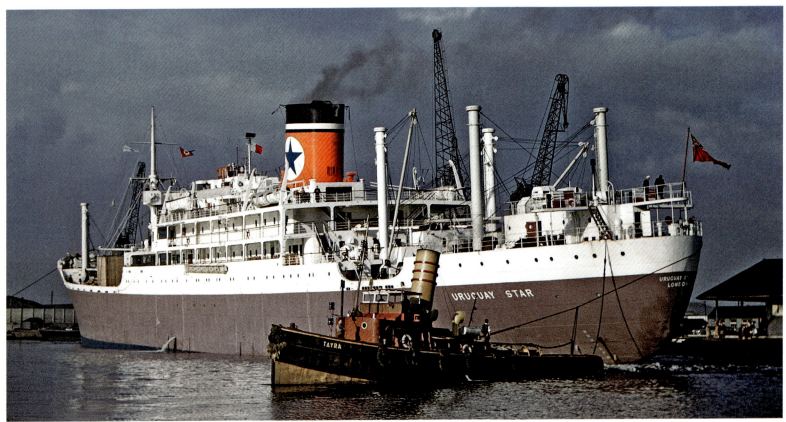

TOP LEFT: The *Brasil Star* was especially popular especially in winter for her sunshine voyages to South America. (Author's collection)
ABOVE: The *Uruguay Star* in the Royal Albert Basin in London Docks, being handled by the Gaselee tug *Tayra*. (Kenneth Wrightman collection)

Booth Line

Hubert, *Hilary* and *Hildebrand*

An arm of Blue Star Line, this Liverpool-based firm used passenger–cargo liners on the UK–West Indies–River Amazon trade. The pre-war *Hilary* was joined by the 170-passenger *Hildebrand* in 1951 and then a sister, the *Hubert*, in 1955. The *Hildebrand* was wrecked off the Portuguese coast in September 1957, leaving only two ships in Booth passenger service between Liverpool, Leixões, Lisbon, Madeira, Barbados, Trinidad, Belém and – going 1,000 miles along the River Amazon – to Manaus.

A Booth Line steward sailed aboard the *Hilary*, *Hildebrand* and *Hubert*:

> These voyages along the Amazon were hot, steamy, thickly and uncomfortably humid. The crew would often sleep on deck. Below, if you opened a porthole, insects of all sizes and types would come flooding in! The ships' navigating officers had to be very careful because of submerged rocks and floating logs in the River. Once, we bent the ship's only screw and then limped to Manaus.

Anselm

The *Anselm* was purchased from the Compagnie Maritime Belge, having been their *Baudouinville* and later *Thysville*, in 1963, but was then soon sold off.

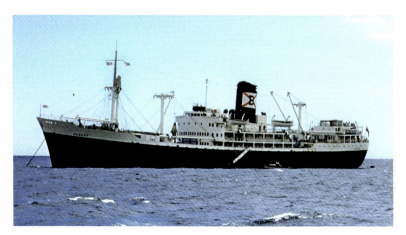

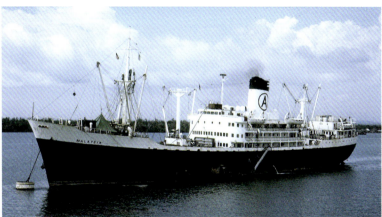

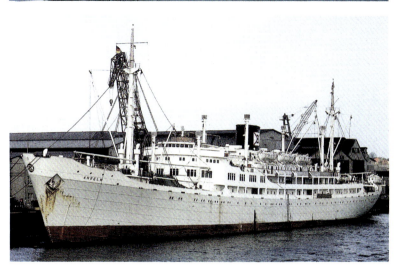

TOP TO BOTTOM:
The *Hubert* anchored in the Amazon. (Mick Lindsay collection); The 8,062-ton, 170-passenger *Hubert* later became the *Malaysia* for Singapore–Australia service. (Mick Lindsay collection); Booth Line's *Anselm* had previously been the *Baudouinville* of the Belgian Line. (Mick Lindsay collection)

British India Line

Kenya and *Uganda*

London-headquartered British India's mainline passenger service was from London to largely colonial British East Africa. Two fine combo liners, the 14,400-ton *Kenya* and her sister *Uganda*, were added in 1951–52. Aboard the *Kenya*, the passengers were typically divided into two classes: 194 in first class and 103 in tourist. The ships were routed between London, Gibraltar and/or Malta, Port Said, Aden, Mombasa, Tanga, Zanzibar, Dar es Salaam and Beira. Homewards, they usually called at Marseilles as well.

The *Kenya* and her sister ship had, in fact, been built for a very specific trade. According to Hans Andresen, a frequent passenger and long-time resident of East Africa:

In the late 1940s, Britain had put millions into the groundnut scheme in Tanganyika. The port of Mtwara was specially created for the expected large flow of both passengers and freight. Therefore, the *Kenya* as well as the *Uganda* were built as particularly large (for British India) combination passenger–cargo ships for the London–East Africa via Suez trade.

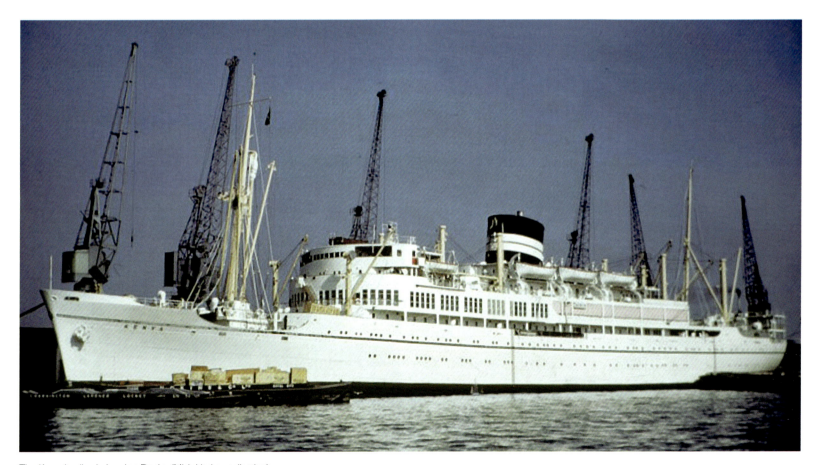

The *Kenya* loading in London Docks. (Mick Lindsay collection)

Great Bygone British Passenger Ships 19

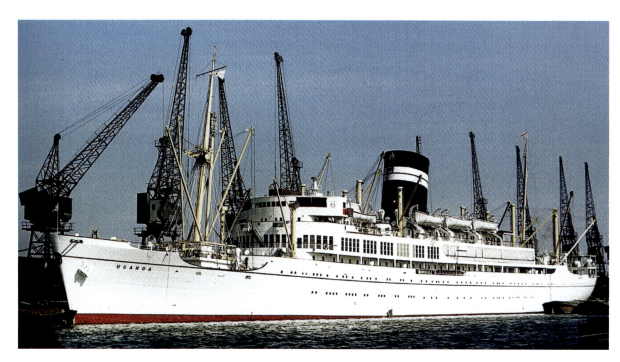

With a taller funnel, sister ship *Uganda* went on to have a second career as a schools' cruise ship. (Mick Lindsay collection)

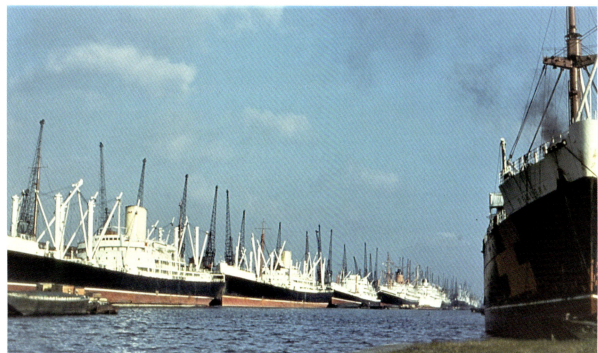

Another busy day in London Docks: the *Gothic* and *Kenya* are in the centre, and the *Remuera* is on the right. (Author's collection)

The *Karanja* at Durban. (Mick Lindsay collection)

Kampala and *Karanja*

Across the Indian Ocean out of South and East Africa, the company operated the 10,300-ton sisters *Kampala* and *Karanja*. These singe-stack ships were designed to carry up to 950 passengers – 60 in first class, 100 in second class and approximately 800 in third class. Generally, they were routed between Bombay, Karachi, the Seychelles, Mombasa, Zanzibar, Dar es Salaam, Beira, Lourenço Marques (modern Maputo) and Durban.

Amra and *Aronda*

In addition, British India – or 'BI', as it was well known – also operated the 8,300-ton *Amra* on the India–East Africa run. Her sister ship, the *Aronda*, operated around India, from Karachi via Colombo to Chittagong (modern Chattogram). Accommodations differed between ships: the *Amra* took 222 so-called saloon and then 737 third-class passengers; the *Aronda* was configured for no less than five classes – 44 first, 22 second, 28 interchangeable, 60 intermediate and up to 1,800 unberthed. In addition, each ship had four holds for cargo.

Sangola, *Sirdhana* and *Santhia*
Mombasa

In its vast network that employed as many as fifteen ships, British India had three passenger ships – the 8,600-ton near-sisters *Sangola*, *Sirdhana* and *Santhia* – operating on the Bengal–Japan run. Configuration of passengers varied, but for the 479ft-long *Sangola*, it was listed as 21 first class, 34 second A, 30 second B and 335 bunked, as well as 995 deck passengers. These slow, 14-knot ships were generally routed from Calcutta (modern Kolkata) to Rangoon, Penang, Singapore, Hong Kong, Yokohama and Kobe.

Rajula

A second service, employing the veteran, 1926-built *Rajula*, carrying some 1,800 passengers, was operated between Madras (modern Chennai), Nagapattinam, Penang and Singapore.

Dara, *Daressa*, *Dumra* and *Dwarka*

A third mid-eastern route was the Bombay–Gulf service, which employed four smallish 5,000-tonners: *Dara*, *Daressa*, *Dumra* and *Dwarka*. These ships were very popular and used on a service from Bombay and Karachi to the Persian Gulf – to Pasni, Gwadar,

RIGHT: Dubbed the 'Queen of the Gulf' in her later years, the *Dwarka* is seen loading at Bombay. (British India Society)

Muscat, Bandar Abbas, Sharjah, Dubai, Umm Sa'id, Bahrain, Bushire (modern Bushehr), Kuwait, Abadan, Khorramshahr and Basrah. Accommodations among the ships varied but, as an example, aboard the *Dwarka*, these were listed as 13 first class, 41 second and 1,050 deck passengers. For over a century, British India passenger services were bywords in mid-eastern travel.

Nevasa, Dilwara, Dunera and *Devonia*

British India also owned at least three peacetime troopships: the 1,500-passenger *Nevasa*, added in 1956, and the sisters *Dunera* and *Dilwara*, which each carried up to 1,300 passengers and dated from 1937.

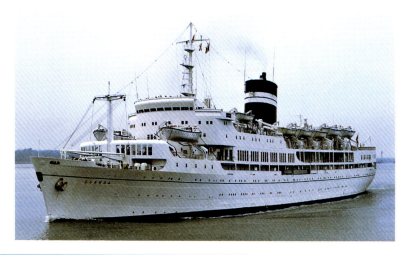

After having served on the London–East Africa run, the *Uganda* began a second career as an educational cruise ship in 1966–67.(Mick Lindsay collection)

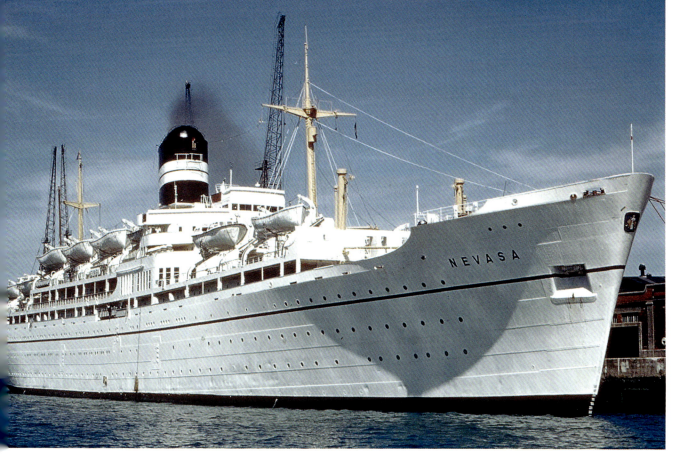

The *Nevasa* was commissioned in July 1956, the centenary year for British India. (David Williams collection)

The 1937-built *Dunera* was used for British Government trooping to Hong Kong, Singapore and even during the Korean War in the early 1950s. (Mick Lindsay collection)

The *Dunera* was later converted for British India's educational cruising. (Mick Lindsay collection)

A recent passenger on the *Queen Mary 2*, from Yorkshire, went to London in his younger days, joined the office of British India Line (at 3 Aldgate), and was later sent to sea, serving on the schools cruise ships, *Nevasa*, *Dilwara* and *Devonia*:

> We did all sorts of cruises – the Med, western Europe, Scandinavia, the Northern Cities, even the isles of Scotland. The passengers were divided – a few hundred adults up forward, then hundreds of British school kids in dormitories in aft sections. The two joined together, however, for top-notch lectures and classes – about history, art, foreign cultures. It was all very, very popular back then – and very affordable.

Canadian Pacific

Empress of Canada, *Empress of France* and *Empress of Scotland*

This diverse company, which had planes, trains, ferries, coastal passenger ships and even trucks, maintained a transatlantic service between Liverpool, Greenock, Quebec City and Montreal. In winter, from December through March, it terminated at St John, New Brunswick; otherwise, their liners were sent cruising from New York to the Caribbean. In the early 1950s, a weekly service was maintained by three liners: the *Empress of Canada* (1928), the *Empress of France* (1928), and the larger, three-funnel *Empress of Scotland* (1930).

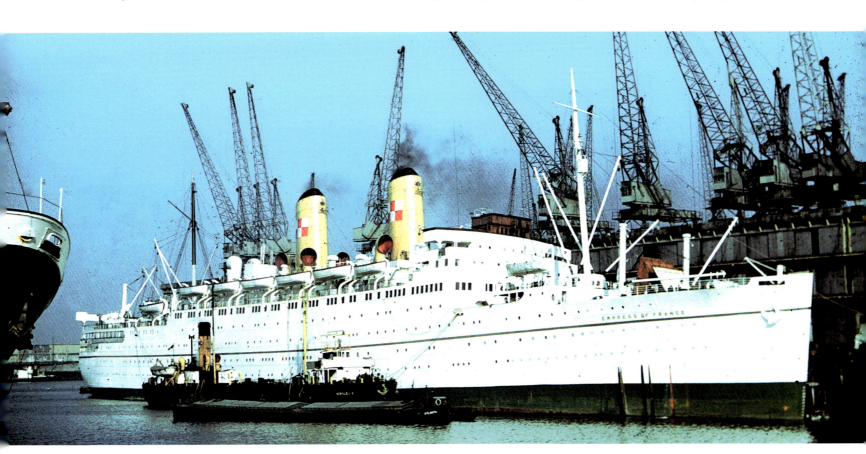

The classic, twin-funnel *Empress of France*, seen here at Liverpool, had been the *Duchess of Bedford*. She dated from 1928. (David Williams collection)

24 British Passenger Liners in Colour

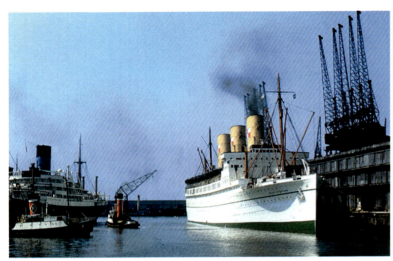

The three-funnel *Empress of Scotland* had been, until 1942, the *Empress of Japan* and used in trans-Pacific service. (Mick Lindsay collection)

Seen at Montreal, the 666ft-long *Empress of Scotland* carried the then Princess Elizabeth and Duke of Edinburgh home from Canada to Liverpool in November 1951. (ALF collection)

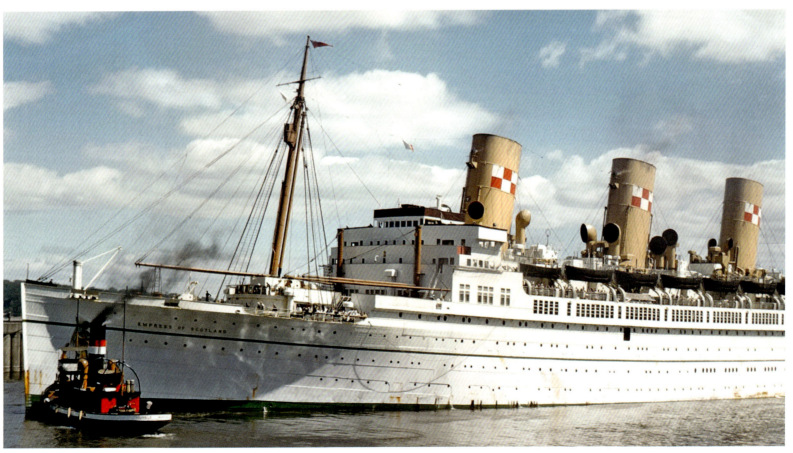

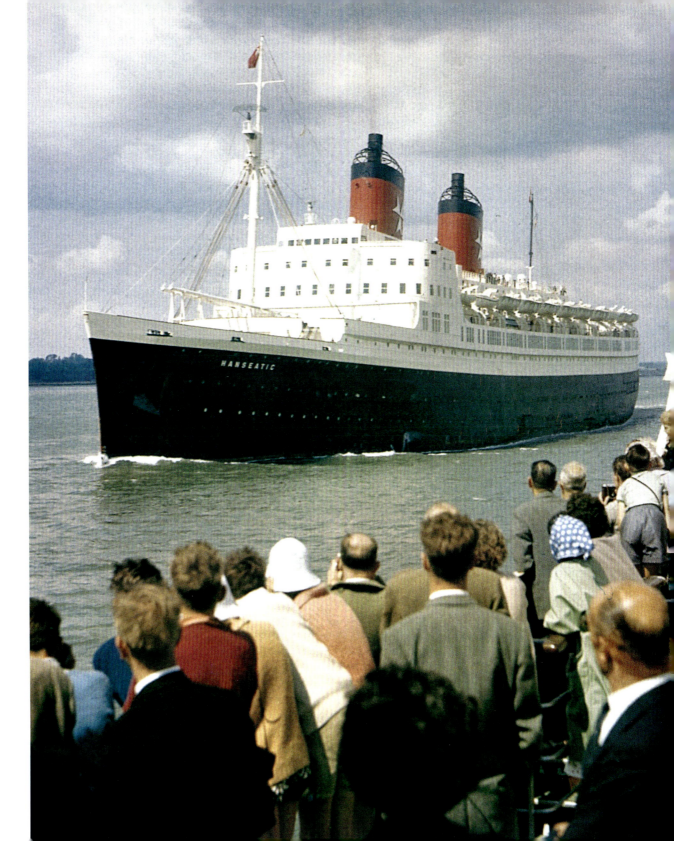

In 1957–58, the *Empress of Scotland* was thoroughly rebuilt as the *Hanseatic* of the Hamburg Atlantic Line. (Author's collection)

Empress of Australia

When the *Empress of Canada* burned and capsized in January 1953, the company quickly purchased the French Line's *De Grasse* and pressed it into service as the *Empress of Australia*.

Empress of Britain and Empress of England

In 1956–57, Canadian Pacific added two 25,500-ton sisters, the *Empress of Britain* and the *Empress of England*. The 1,054-passenger *Empress of Britain* was, in fact, Britain's first fully air-conditioned liner when completed in April 1956. While the older *Empress of Scotland* and *Empress of Australia* were sold off, the veteran *Empress of France* continued to assist the two new company liners until 1960.

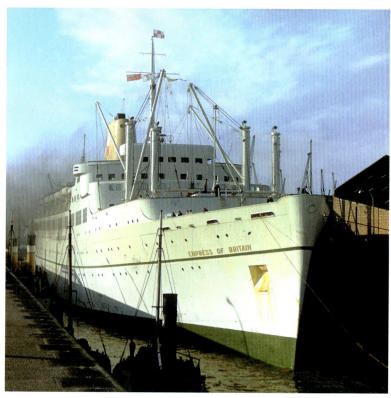

RIGHT: Launched by HM Queen Elizabeth II on 22 June 1955, the *Empress of Britain* went on to have a very long and varied career. (Mick Lindsay collection)

BELOW: Seen at the breakers at Alang in India in August 2008, and with the former *Norway* behind, the then 52-year-old ship had also been the *Queen Anna Maria*, *Carnivale*, *Fiesta Marina*, *Olympic*, *Topaz* and even sailed as the *Peace Boat*. (Peter Knego collection)

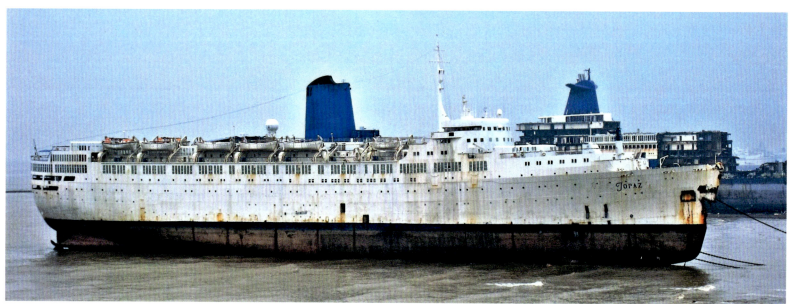

Empress of Canada (1961)

The *Empress of Canada*, completed in 1961, was part of the last high water of construction for British passenger ships. The group included the *Pendennis Castle*, *Windsor Castle* and *Transvaal Castle*; *Northern Star*; the sisters *Amazon*, *Aragon* and *Arlanza*; and, largest of all, the *Oriana* and *Canberra*.

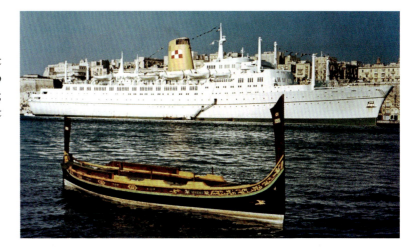

The handsome *Empress of Canada* seen at Valletta, Malta, during a nine-week winter Mediterranean cruise. (Author's collection)

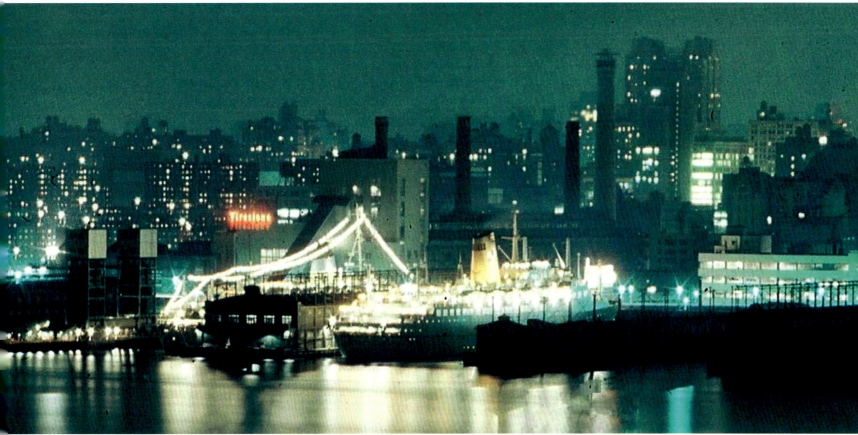

Nightfall: the *Empress of Canada* and Greek Line's *Olympia* at New York's Pier 97 in January 1968. (Author's collection)

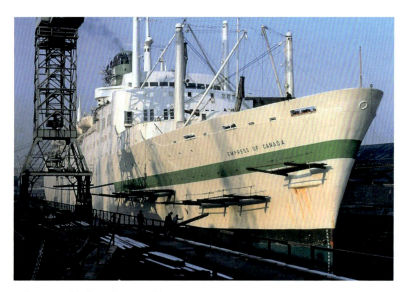

In December 1968, the *Empress of Canada* was repainted at Liverpool in Canadian Pacific's new, updated green colours. (Author's collection)

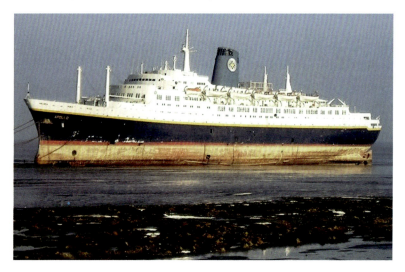

Having been Carnival's *Mardi Gras* and then the *Star of Texas, Lucky Star, Olympic* and finally *Apollo*, the former *Empress of Canada* arrived at Alang in India on 4 December 2003 and was beached in preparation for scrapping. (Peter Knego collection)

Cunard Line

Queen Elizabeth and *Queen Mary*

Few shipping lines are more historic, well known or as popular as the Cunard Line. Dating from 1840, this Liverpool-based firm had the largest fleet on the North Atlantic run in the 1950s and carried more passengers than any other line. In 1958, Cunard had twelve passenger ships making Atlantic crossings, which often included four sailings a week from New York.

The company fleet was, of course, headed by the two Queens: the 81,237-ton, 1,957-passenger *Queen Mary*, completed in 1936, and the largest liner then afloat, the 83,673-ton, 2,233-passenger *Queen Elizabeth*. Fast, sturdy and well run, these three-class liners spent eleven months of their year on the 'express run' between Southampton, Cherbourg and New York. They were the most famous, popular and financially successful pair of ocean liners ever to sail.

'The *Queen Mary* was a ship with that sense of having a hidden soul, something different from the steel, wood, nuts and bolts. The feeling sort of embraced you,' recalled Cunard chef Dave Smith.

Bruce Nutton, a passenger in the 1950s and '60s, added:

You just loved being on board almost from the moment you stepped across the gangway. We do 3 trips in her. She was different than the French liners, however. She was more like some grand old British country house filled with traditions, order, a sense of stately solitude. The staff, again in first class, were Cunard trained and mannered down to their little fingers. It was all very proper. I remember thinking the chef looked like a winter snowman. He came to our table, with a silver trolley and to carve the finest beef you ever tasted, in an all-white uniform and a big puff hat. It was all done with a seriousness – there was no idle chit-chat, but highly trained manners. Yes, the *Queen Mary* was like the best run country house, a sort of *Downton Abbey* on the seas.

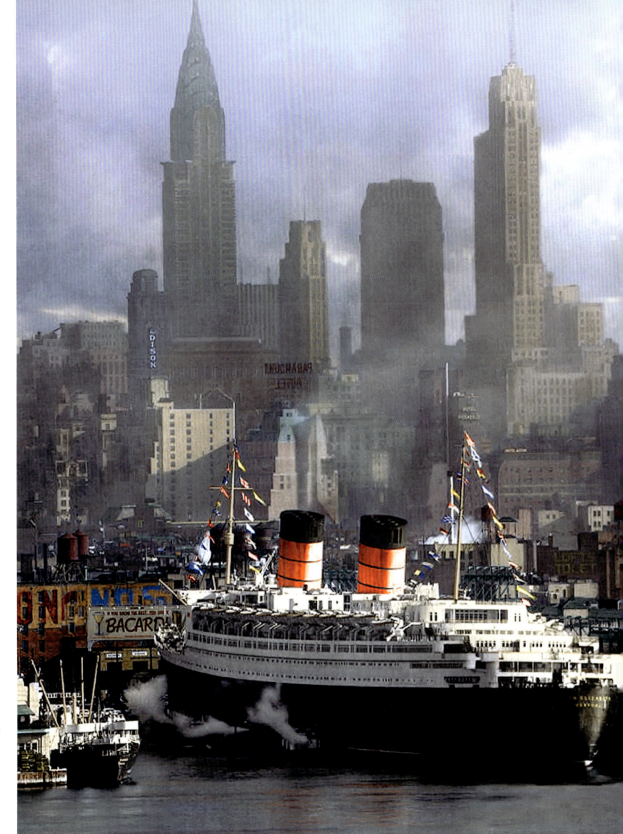

Glorious return! On 6 March 1946, the *Queen Elizabeth* was the first Cunarder released from war service. After a full refit, the 1,031ft-long liner – then the world's largest ocean liner – resumed service between Southampton and New York the following October. (Author's collection)

30 British Passenger Liners in Colour

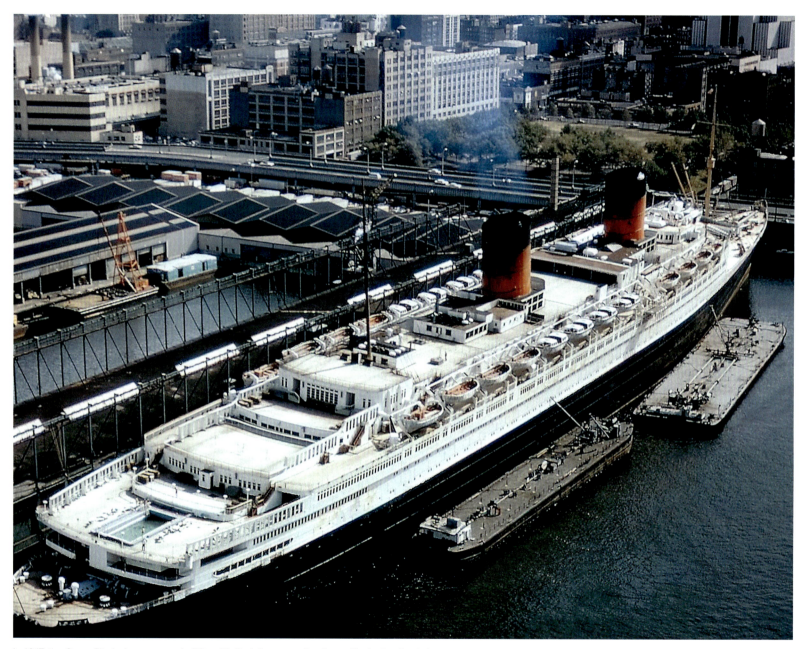

In 1947, the *Queen Elizabeth* was aground off Bramble Bank for twenty-four hours. (Author's collection)

Great Bygone British Passenger Ships 31

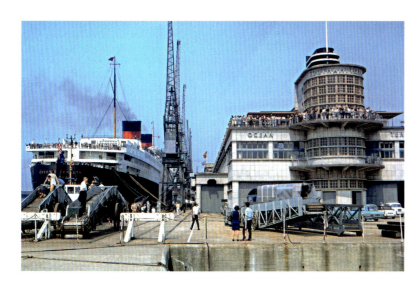

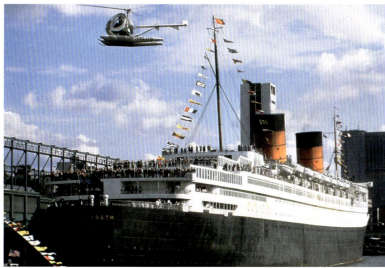

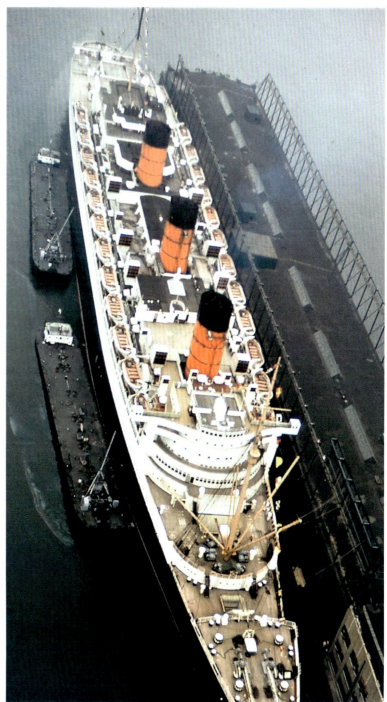

CLOCKWISE FROM TOP LEFT: The Cunard Queens regularly used the iconic Ocean Terminal at Southampton, which opened in 1950 but was demolished in 1983. (Mick Lindsay collection); The *Queen Mary* had a Cunard sailing career of thirty-one years and became one of the most loved and popular liners of all time. (Author's collection); Upon retirement from Cunard service in November 1968, the *Queen Elizabeth* had completed a record of 907 Atlantic crossings, travelled 3,470,000 miles and carried 2,300,000 passengers. (Author's collection)

32 British Passenger Liners in Colour

CLOCKWISE FROM RIGHT: From August 1938 until July 1952, the *Queen Mary* held the Blue Riband. She was the fastest liner afloat. (Cunard Line); During the Second World War, in July 1943, the *Queen Mary* carried a record number aboard a ship: 16,683 soldier-passengers and crew. (Author's collection); New York's 'Luxury Liner Row' almost always included a Cunard liner. In this view from September 1957, from top to bottom, there is the *Constitution*, *United States*, *Olympia*, *Flandre*, *Mauretania*, *Queen Mary* and *Britannic*. (Author's collection)

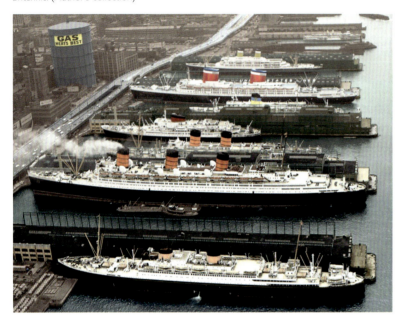

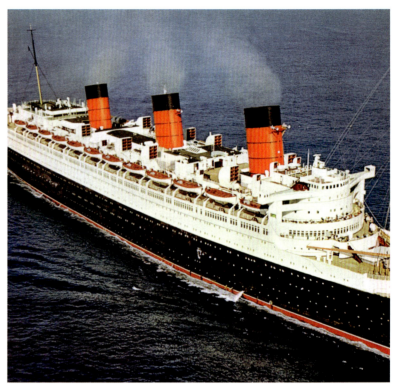

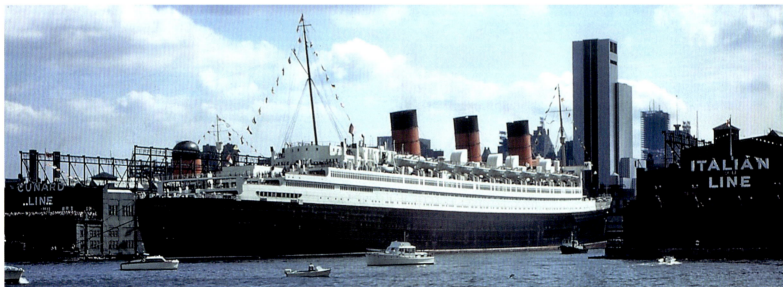

Dave Smith also remembered:

Once I was given a $20 tip for making a proper BLT sandwich. It was from Rock Hudson. On Cunard, it was an all-British crew back then – the 'Mushers' from Southampton, Cockneys from London, Scousers from Liverpool and Jordies from Newcastle. You had to belong to the NUS, the National Union of Seamen, to get a job. And there was a Union rep onboard. Myself, I was earning about 250 pounds a year – or about $600.

Another passenger recalled crossing roundtrip on the *Queen Elizabeth* in 1961. She remembered those swift five-day passages between New York and Southampton:

I especially remember there was a Daily Tote, run outside the ship's shops at lunchtime. It was 50 cents to enter. It was a mileage pool based on the ship's noon reading. But at night, there was a Sweepstakes. That was the big money and sometimes very big money, maybe as much as $100!

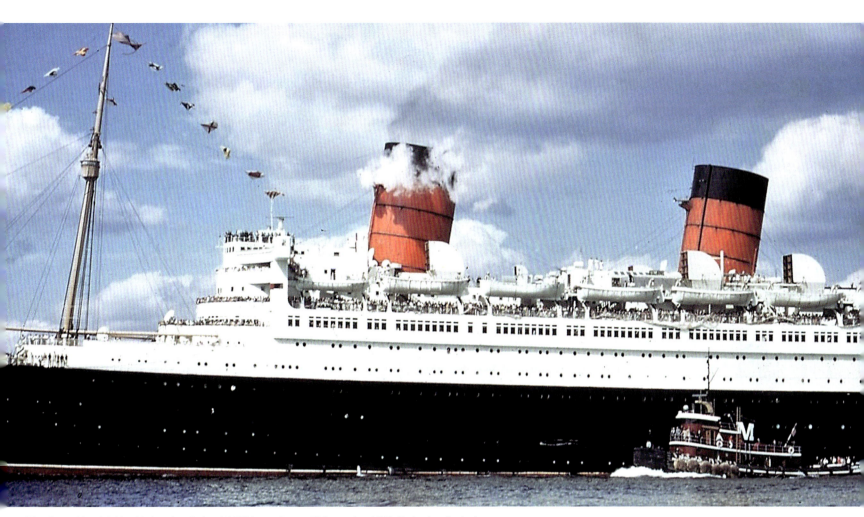

The *Queen Mary* left New York on her final and 1,000th crossing on 22 September 1967. (Author's collection)

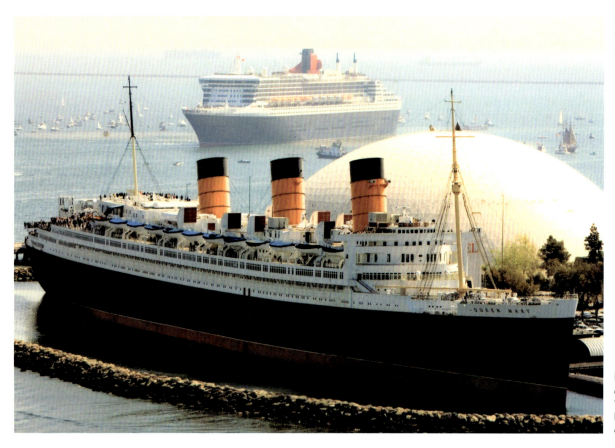

In January 2006, the *Queen Mary 2* 'met' the *Queen Mary* at Long Beach, California. (Cunard Line)

In December 1962, the 772ft-long *Mauretania* was repainted in Cunard's 'cruising green' and assigned to Mediterranean–New York service as well as on more cruises. (Author's collection)

Mauretania and *Caronia*

The 35,655-ton *Mauretania* offered assistance on the main run, but between Southampton, Le Havre, Cobh and New York. The green-coloured, 34,172-ton *Caronia* – used mostly for long, luxurious cruises from New York – made occasional crossings between Southampton, Le Havre and New York, and in winter via Caribbean ports Nassau and Bermuda.

Shipboard grandeur! Cyril Smith was a cabin steward in the 1950s and '60s aboard Cunard's *Caronia*, the legendary 'Green Goddess' and a very luxurious ship that just roamed the world on one long cruise after another:

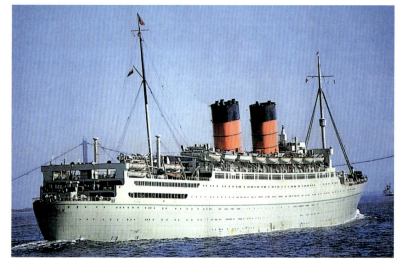

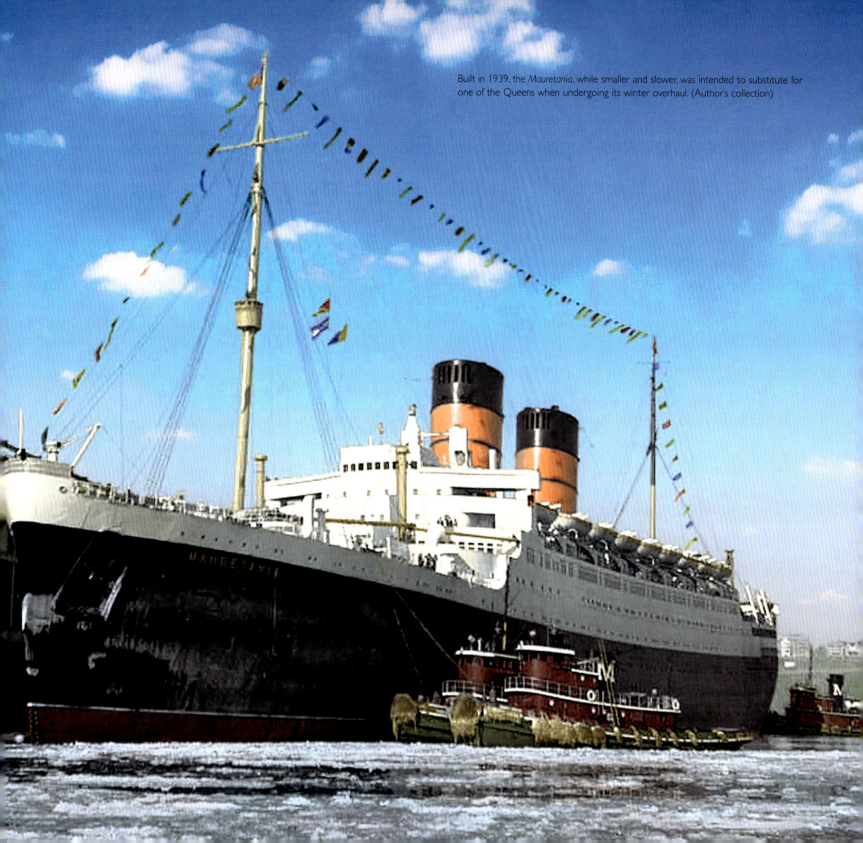

Built in 1939, the *Mauretania*, while smaller and slower, was intended to substitute for one of the Queens when undergoing its winter overhaul. (Author's collection)

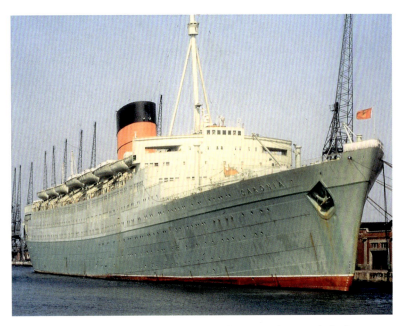

Completed in late 1948, the *Caronia* was considered by many to be not only the finest Cunarder, but the most luxurious liner afloat. It had a loyal following, including one passenger who lived aboard for fourteen years. (David Williams collection)

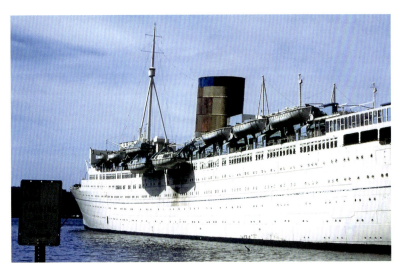

Sold to Panama-flag owners in 1968 and renamed *Caribia*, the former *Caronia* loitered about New York Harbor, bankrupt and shifting from berth to berth. In the end, she was wrecked on Guam in August 1974 while being towed to Taiwan for breaking. (Author's collection)

We carried many, many American millionaires, including many rich older ladies. Some would come year after year – and a few even wanted the same cabin and even the same stateroom steward. They liked a sense of the familiar, like some grand club. One lady brought 300 dresses for the 95-night world cruise, another her favorite chair and one couple had cases of their favorite wine. Some rarely left the ship. They'd been just about everywhere and so the *Caronia* was like their big yacht. They'd just glance at places like Bombay and Hong Kong from the deck. Some played bridge every day and a few even had platters of lunchtime sandwiches delivered to the ship's card room. There were long naptimes in the afternoon – the whole ship seemed to be sleeping! In the evenings, the *Caronia* was very, very formal. There were the most fantastic parties, mostly arranged by the passengers, and mostly themed. Passengers dressed to the invitation. I remember one was the 'Night of the Maharaja's' and another 'Chinese Lanterns'. But it was formal dress almost every night, except Sunday of course. Ladies wore full gowns and the most fabulous jewels. At Cunard in those days, we used to say that the *Caronia* was more formal and even more luxurious than first class on the *Queen Mary* and *Queen Elizabeth*. Many, many Cunard crew wanted to be assigned to the *Caronia*. $500 and even $1,000 tips were not uncommon – and these were huge amounts back in the 1950s.

Britannic, *Media* and *Parthia*

Cunard also ran a regular service from Liverpool via Cobh to New York, using the 1930-built *Britannic* and the combo sister ships *Media* and *Parthia*. While the *Britannic* carried almost 1,000 passengers in two classes, *Media* and *Parthia* were all-first class and had only 250 berths.

Great Bygone British Passenger Ships 37

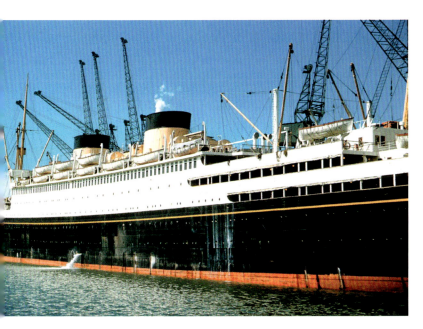

When retired in December 1960, the *Britannic* was the last of the original White Star Line ships, a company that merged with Cunard in 1934 and then traded as Cunard-White Star until 1950. (David Williams collection)

The *Media* and *Parthia* spent six days at New York between crossings. (Author's collection)

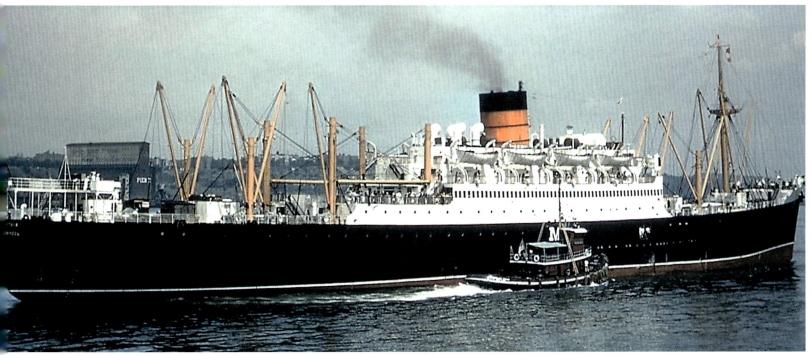

Aquitania

Simple standards! Hillary Gordon recalled:

In 1946, I crossed with my parents between Southampton and Halifax aboard the *Aquitania*. The ship was still in a sort of wartime mode – the standards on board were very simple and all one class. It was called austerity service. There were British immigrants aboard heading to Canada for a new life and also lots of homeless refugees from Eastern Europe. The ship was comfortable enough, but by no means luxurious and had none of the varied shipboard entertainments we have today. Dancing, I think, was the only scheduled activity.

Georgic

In the early 1950s, Cunard also operated the migrant ship *Georgic* on the North Atlantic. Used for low-fare voyages, she could carry as many as 1,962 passengers in all-tourist-class quarters.

Scythia, *Samaria*, *Franconia* and *Ascania*

On its seasonal Canadian run, Cunard ran four veteran liners in the early 1950s: the *Scythia*, *Samaria*, *Franconia* and *Ascania*. Service was from Southampton or Liverpool to Quebec City (but later extended to Montreal).

Stanley Howard recalled: 'I was in the British Army but did not return from posting in Malaya until 1949. I came home through Suez to Liverpool on the Cunard liner *Scythia*, but which was still gray colored, wartime drab and trooping four years after the War ended.' Some liners 'trooped' for years after the Second World War and only then returned to their owners and commercial service. The *Scythia* resumed Cunard liner sailings in August 1950, five years after the war had ended.

A final crossing for *Aquitania*, the last four-stacker. (Australian National Maritime Museum)

Great Bygone British Passenger Ships 39

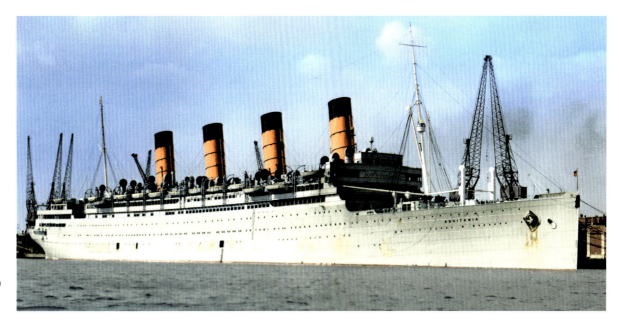

The *Aquitania* is seen here at Southampton just after the Second World War, in 1946. (Author's collection)

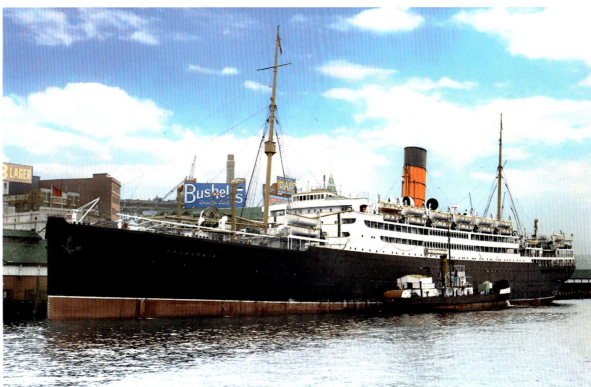

Built in 1923 and used as Winston Churchill's headquarters during the Yalta Conference in February 1945, the *Franconia* endured until December 1956. (Author's collection)

Saxonia, Ivernia, Carinthia and *Sylvania*

The four veteran ships were replaced, beginning in 1954 with a brand-new class of 23,000-tonners: the *Saxonia, Ivernia, Carinthia* and *Sylvania*. In winter, these ships were routed to Halifax and New York – crossing alternately from London, Le Havre, Southampton and Cobh, and from Liverpool and Cobh.

By age 16, Graham Lees felt strongly about his career: he wanted to go to sea and he wanted to be a steward. But his father objected. His father said stewards were the 'gypsies of the sea'. So, since Graham was also interested in radios, he trained to become a ship's radio officer. In 1965, he was ready and joined the International Radio Company, and was soon assigned to the *Carinthia* of the Cunard Line. He would spend thirteen months on board that ship as a radio officer. Graham recalled:

In the *Carinthia*, we were on the Atlantic run – from Liverpool and Greenock across to Quebec City and Montreal. We would take on most passengers at Liverpool, but then load whiskey, mail and a few passengers (maybe only 50) at Greenock. We would later discharge most of the cargo [there were six hatches on the 22,000-ton, 875-passenger *Carinthia*] at Quebec City and then go to Montreal, where we would spend 3 nights. I remember construction was just beginning on Expo 67, the big exposition. On the return, we would have 4 nights in Liverpool, arriving on Monday mornings. We would discharge the passengers at the Princes Landing Stage and then shift to the Canada Dock for cargo handling. Moving the ship all had to be done carefully, according to the Mersey tides and getting the ship through the dock locks.

In winter, when the St Lawrence was closed because of ice, we would sail to Halifax and then to New York. I remember we would

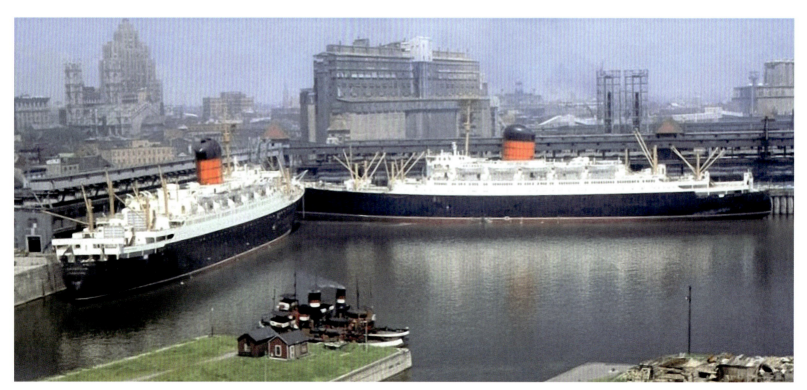

Cunard's Canadian service was greatly improved with the creation of four sister ships – *Saxonia, Ivernia, Carinthia* and *Sylvania* – in 1954–57. In this view at Montreal, the *Carinthia* and *Ivernia* are seen together. (ALF collection)

Great Bygone British Passenger Ships 41

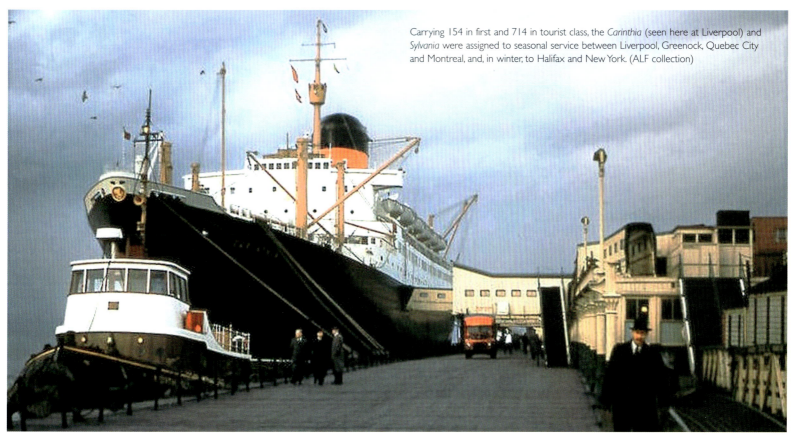

Carrying 154 in first and 714 in tourist class, the *Carinthia* (seen here at Liverpool) and *Sylvania* were assigned to seasonal service between Liverpool, Greenock, Quebec City and Montreal, and, in winter, to Halifax and New York. (ALF collection)

RIGHT: Alternately, the *Saxonia* and *Ivernia* (seen here at Southampton) sailed between Southampton, Le Havre, occasionally Cobh, Quebec City and Montreal. (ALF collection)

have some very serious and very extensive US Coast Guard as well as US Customs inspections. Once, I recall sending a message to one of our sister ships, the *Franconia*, which was arriving the next day from a cruise in the Caribbean. Quickly, the crew on the *Franconia* were opening portholes, even along the Hudson River, and dumping overboard lots of illegal liquors, especially rums.

Graham later 'stood by' the idle *Carinthia* and another sister, the *Sylvania*, at Liverpool during the six-week British seamen's strike (May to June 1966). 'The ships were all but silent – with only skeleton crews,' he added.

42 British Passenger Liners in Colour

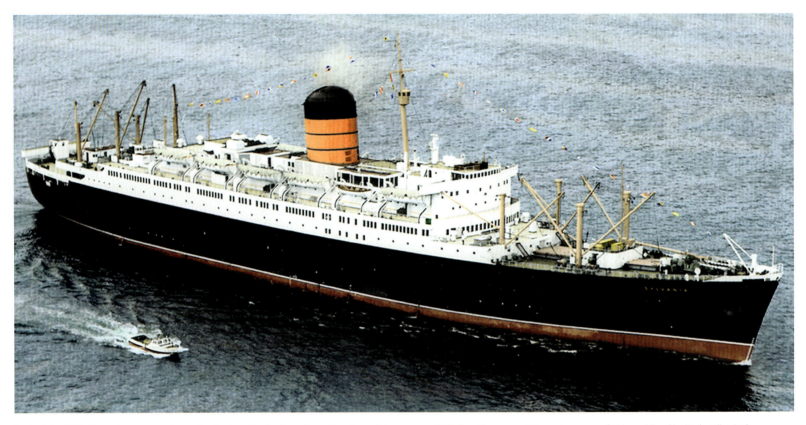

By the late 1950s, Cunard management regretted not making the *Saxonia* and her three sisters more suitable for off-season, winter and more profitable cruising. (Author's collection)

In 1962–63, both the *Saxonia* and *Ivernia* were taken in hand for major refits. They were repainted entirely in green and given full air-conditioning, a lido deck and improved passenger accommodation. They were also given new names: the *Saxonia* became *Carmania*, while the *Ivernia* changed to *Franconia*. (ALF collection)

Great Bygone British Passenger Ships 43

Carmania and *Franconia*

In April 1967, the *Franconia* began weekly cruise service between New York and Bermuda, replacing the Furness Bermuda Line. (Author's collection)

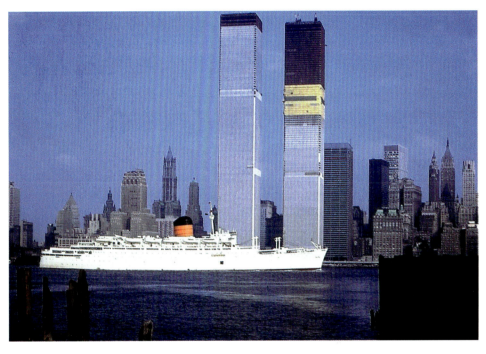

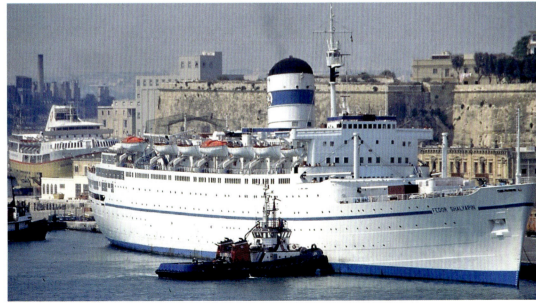

Sold off in 1973, the *Franconia* went to Soviet owners, the Odessa-based Black Sea Steamship Company, and became *Feodor Shalyapin* (seen here at Valletta, Malta, in August 1993). Sister ship *Saxonia* became the *Leonid Sobinov*. (Author's collection)

Queen Elizabeth 2

A long-retired engineer once told the author:

I was at Vickers [Vickers-Armstrong, the noted shipbuilder] in the early '60s and we were asked by Cunard to prepare initial studies and plans for two new Queens as well as for one big liner but which would be nuclear-powered. Both ideas died quickly, especially since the Government wasn't interested in giving financial assistance. We worked as well on the three-class Q3 Project, but that died as well – it was simply outdated from the start. Instead, the *QE2* was created and that job didn't even go to Vickers, but to John Brown up on the Clyde. But up until 1965, Cunard was unsure of what kind and size of liner they actually wanted or fitted in to their future of crossings and cruises.

Terry Foskett is a former purser on Canadian Pacific's Empress liners and later on the iconic *QE2*. He was aboard when the Cunard flagship was called to duty in the South Atlantic for the Falklands War. He remembered:

In a dramatic turn of political events, Britain went to war with Argentina over the sovereignty of the remote, tiny Falklands Islands in April 1982. Moving a large number of troops and supplies by sea became a logistical priority. On May 3rd, the British government officially requisitioned the *QE2*. All but yanked from service, the liner was converted in a record 8 days at Southampton to carry over 3,500 troops. Used for two months (and with 600 largely volunteer Cunard crew on board), the Cunard flagship joined other requisitioned passenger ships such as the *Canberra* and *Uganda* in the South Atlantic conflict. Supplied with extra life jackets and safety

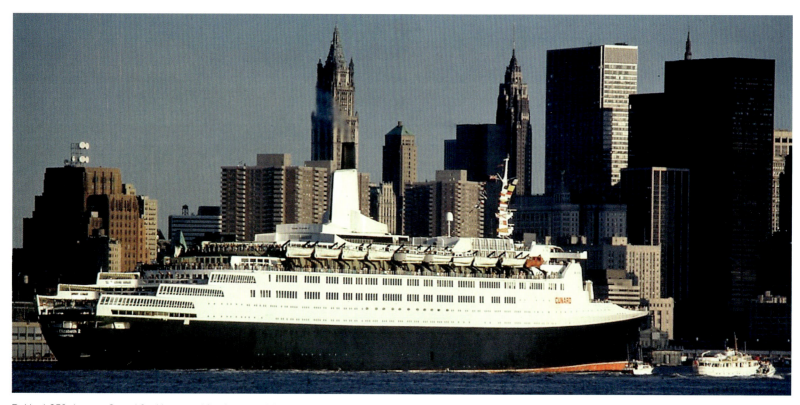

Dubbed *QE2*, the new Cunard flagship entered Southampton–New York service in May 1969. (Author's collection)

Great Bygone British Passenger Ships 45

With its keel laid on 5 June 1965, HM Queen Elizabeth II named the new Cunard flagship *Queen Elizabeth 2* in a launching ceremony on 20 September 1967. (Cunard Line)

equipment, she also carried munitions in her forward hold. She was refueled at sea three times in those distant Southern waters. Serving heroically brought the Cunard liner a great boost in prestige and popularity, especially when she ceremoniously returned to Southampton on June 11th. Among those welcoming the liner, Queen Elizabeth the Queen Mother waved from the decks of the royal yacht *Britannia*, which was waiting in the Solent.

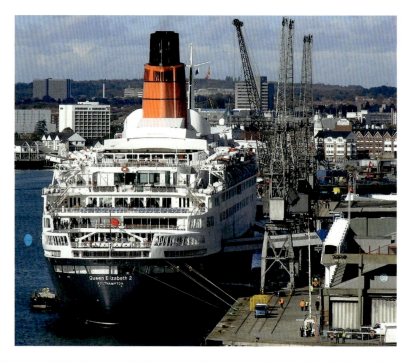

RIGHT: Originally designed to carry 564 first- and 1,441 tourist-class passengers, the 963ft-long *QE2* went on to sail for thirty-nine years and rank as one of the most successful ocean liners of all time. (ALF collection)

BELOW: The *QE2* was called to duty in May 1982 for military service in the South Atlantic during the Falklands War. (Anthony Davis)

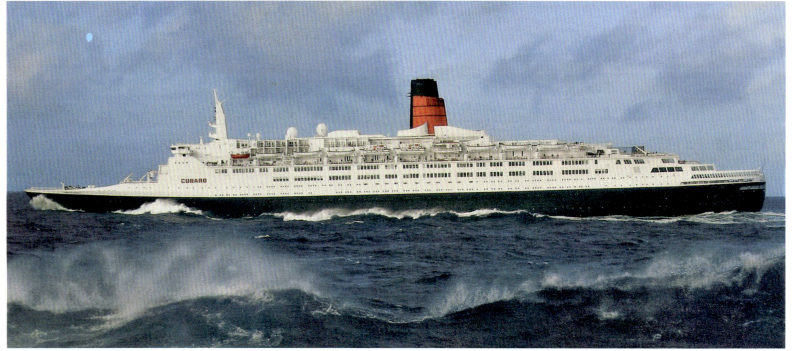

Great Bygone British Passenger Ships 47

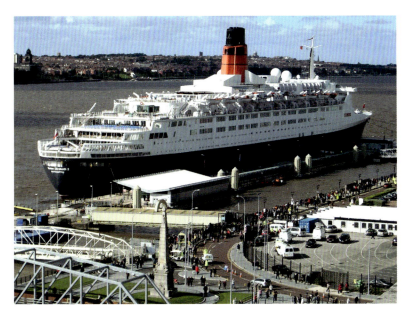

Pictured here at Liverpool in October 2008, the *QE2* would set sail for the last time a month later, having been sold for $100 million and intended for conversion into a museum, hotel and luxury condominiums in Dubai. Long delayed, it finally opened as a hotel in April 2018. (Author's collection)

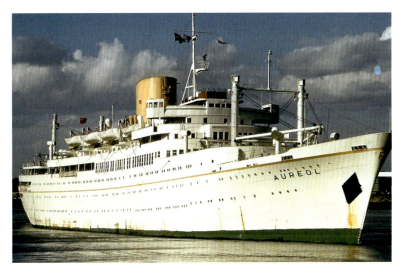

As flagship of the Elder Dempster Lines and finest ship on their West African passenger service, the 537ft-long *Aureol* was often appraised as being 'yacht like'. (Mick Lindsay collection)

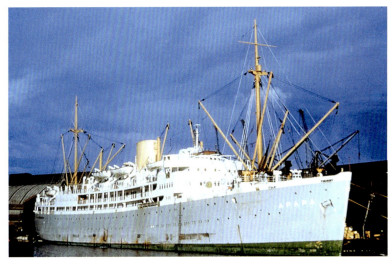

The *Aureol* was assisted in maintaining a fortnightly service from Liverpool by two smaller sister ships, the 11,600-ton *Accra* and *Apapa* (seen here at Liverpool). (Mick Lindsay collection)

Donaldson Line

Laurentia and *Lismoria*

Having had two liners in Atlantic service between the First and Second World Wars, Glasgow-headquartered Donaldson Line opted for only two freighter conversions in the late 1940s. The fifty-five-passenger *Laurentia* and *Lismoria* were rebuilt, having been 1944–45-built Victory ships. They sailed in the Glasgow–Montreal direct service from April through December, to the North American west coast via Panama, and later to St John, New Brunswick, and Halifax in winter.

Elder Dempster Lines

Aureol, *Accra* and *Apapa*

This well-known British shipping line was nicknamed the 'ED Lines'. A subsidiary of the mighty Blue Funnel Line, this firm maintained a fortnightly service between Liverpool, Las Palmas, Freetown, Takoradi, Lagos and Apapa. The 14,083-ton, 275-passenger *Aureol* was assisted by 11,600-ton sisters *Accra* and *Apapa*.

Calabar, *Winneba*, *Tamele* and *Tarkwa*

Secondary services offered included sailings to the same West African ports, but from London using the pre-war built sister ships *Calabar* and *Winneba*, which carried 105 passengers in all-first-class quarters. Two other ships, the *Tamele* and *Tarkwa*, carried only forty passengers each in a service between Liverpool, Port Harcourt and other West African ports.

Elders and Fyffes Ltd

Golfito and *Camito*

Also known as the Fyffes Line, this British company was well known for its 'banana boats'. Along with a fleet of white-hulled freighters, the company operated two passenger ships: the 100-passenger near-sisters *Golfito* (1949) and *Camito* (1956). Generally, they operated from Southampton to Barbados, Trinidad, several Jamaican ports and Bermuda. Each 8,600-ton ship, with four cargo holds, could carry some 1,400 stems of bananas.

Audrey Roberts remembered her first voyage – a four-week trip by banana boat from Southampton to the sunny Caribbean:

> We sailed to Trinidad, Barbados, Grenada, Kingston, Montego Bay and Bermuda. Cargo, mostly loading Fyffes bananas was the ship's main purpose, but there was always time in port for some sightseeing. The ship was named *Golfito* and belonged to the Fyffes Line. It carried, as I remember, only 100 passengers – all first class.

> My auntie and I were proper English ladies on tour – flowery dresses, sunhats and fringed parasols to shade us from the hot sun. In the afternoons, my auntie would nap in the stateroom and then rise in time for tea in the lounge. Dinner began late, at 8:30 p.m. as I recall, and was a rather long affair. We almost always dressed formally. It was all rather genteel, like staying in some old hotel. There were no cabaret shows or those twelve-piece bands or even a cruise director. There was dancing, games like frog racing and film showings, which as I remember, were twice a week. It was a lovely opportunity for a young girl to sail the Caribbean in winter – but it was also like something from another age. Yes, genteel is the right word – that trip on the *Golfito* was genteel.

The *Camito* and *Golfito* (both left) were laid up at Southampton among many passengers during the massive British maritime strike in May–June 1966. (Author's collection)

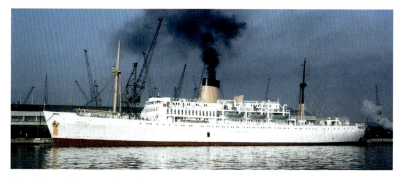

The *Golfito* and her near-sister *Camito* were especially popular for winter-season roundtrip voyages to the sunny Caribbean. (Mick Lindsay collection)

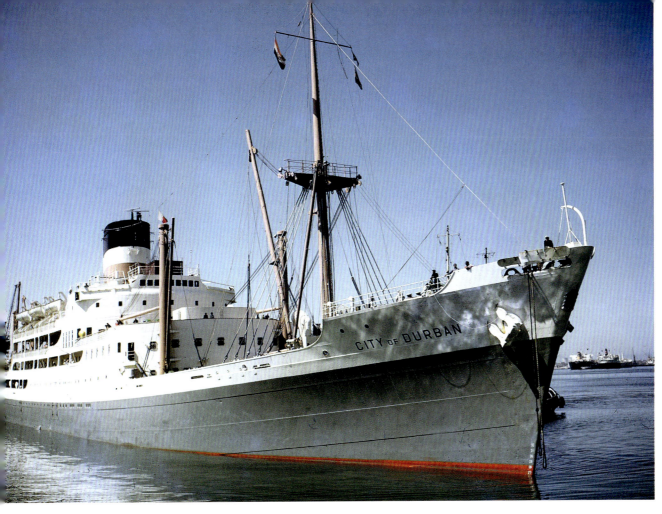

The *City of Durban* and her three sisters had extremely comfortable passenger quarters ; indeed, some travel circles said they offered the finest comfort and service to South and East Africa. (Mick Lindsay collection)

Ellerman and Bucknall Line

City of Port Elizabeth, *City of Exeter*, *City of York* and *City of Durban*

This company was known to have four of the very finest passenger ships on the South African run. Part of a large fleet of freighters, the four sister ships – *City of Port Elizabeth*, *City of Exeter*, *City of York* and *City of Durban* – ran a monthly service from London via Las Palmas to Cape Town, Port Elizabeth, East London, Durban, Lourenço Marques (modern Maputo) and Beira. The passage between London and Cape Town took sixteen days. Built between 1953 and 1954, these 13,400-ton ships each had five cargo holds and could carry up to 107 passengers in very comfortable, all-first-class quarters.

Ellerman's Wilson Line

Borodino

Amidst this line's very large fleet, the thirty-six-berth *Borodino* was the only ship to carry more than twelve passengers. Used on the run between Hull, Copenhagen and Aarhus, the 3,200-ton ship was also designed specially to carry dairy products. The 312ft-long vessel was built in 1950 at Troon.

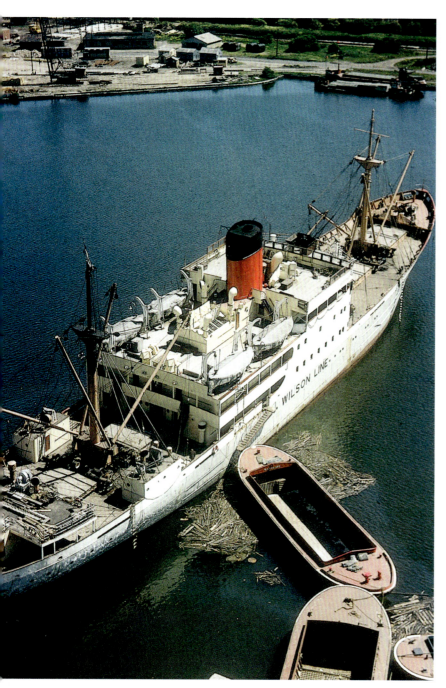

Although small and hardly luxurious, the *Borodino* was especially popular for summertime voyages to Denmark. (David Williams collection)

Furness Bermuda Line

Queen of Bermuda and *Ocean Monarch*

A division of the London-based Furness, Withy and Company, this very popular line specialised in cruise and holiday services between New York and Bermuda: six-day roundtrips departing from New York, usually on Saturdays. The 733-passenger, all-first-class *Queen of Bermuda* resumed sailings in 1949 and then was joined two years later by the smaller, yacht-like, 440-passenger *Ocean Monarch*. Some sailings were extended to include a call at Nassau. The 13,654-ton *Ocean Monarch* made seasonal cruises: summers to eastern Canada, winters in the Caribbean.

Furness Warren Line

Newfoundland and *Nova Scotia*

One of the smaller transatlantic shipping lines, this arm of the mighty Furness, Withy and Company ran two combo liners, the 7,400-ton sisters *Newfoundland* and *Nova Scotia*, between Liverpool, St John's (Newfoundland), Halifax and Boston. Sailings were every three weeks. These 440ft-long ships could carry up to 154 passengers (62 in first and 92 in tourist class). For winter sailings, their hulls were especially strengthened for ice.

Glen Line

Breconshire, Glenartney, Glenearn, Glengyle, Glenorchy, Denbighshire, Glengarry and *Glenroy*

This company had a large fleet of freighters, many carrying six to twelve passengers but others with accommodation for up to eighteen one-class passengers. These 9,000-ton ships included the *Breconshire, Glenartney, Glenearn, Glengyle, Glenorchy, Denbighshire, Glengarry* and *Glenroy*. They were routed from UK ports (Liverpool, London, Glasgow, etc.) via north European ports (Hamburg, Rotterdam, Antwerp, etc.) then via Port Said to Singapore, Hong Kong, Kobe and Yokohama (and other Far East ports according to cargo requirements). They usually returned to the UK via Colombo.

Great Bygone British Passenger Ships 51

The handsome *Queen of Bermuda*, seen berthed along Front Street at Hamilton, Bermuda, was one of the most popular and successful liners of the twentieth century. (Author's collection)

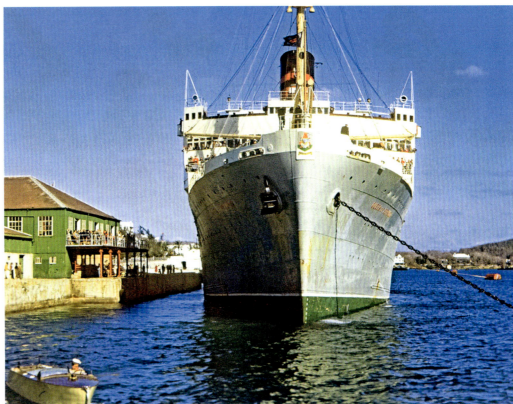

With six-night cruises between New York and Bermuda, the *Queen of Bermuda* was especially popular with the just-married set and was dubbed the 'honeymoon ship'. (Allan Davidson collection)

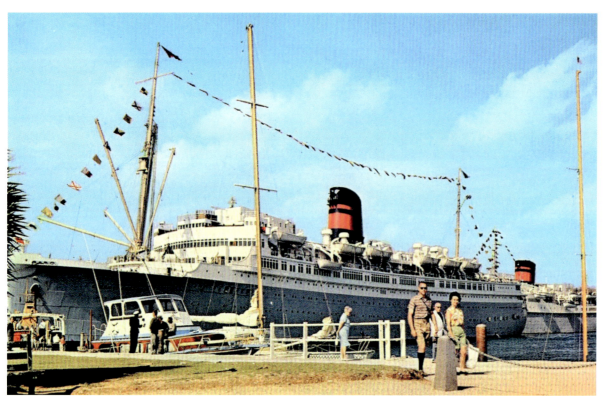

A unique distinction: the 22,500-ton *Queen of Bermuda* sailed as a three-stacker, a two-stacker during the Second World War and then as a single-stacker following a 1961–62 refit. (Allan Davidson collection)

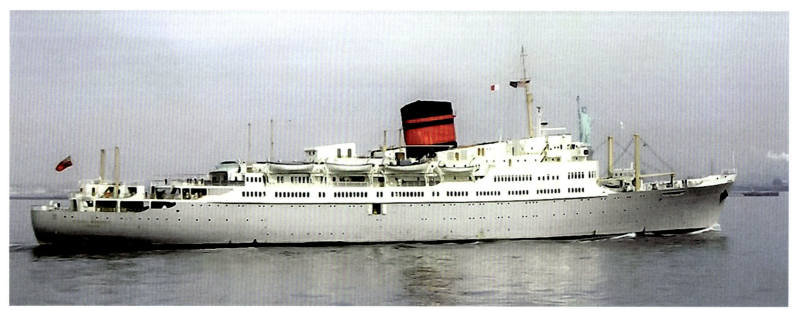

The *Ocean Monarch* was described as being 'yacht-like' and a consort to the larger *Queen of Bermuda*. (ALF collection)

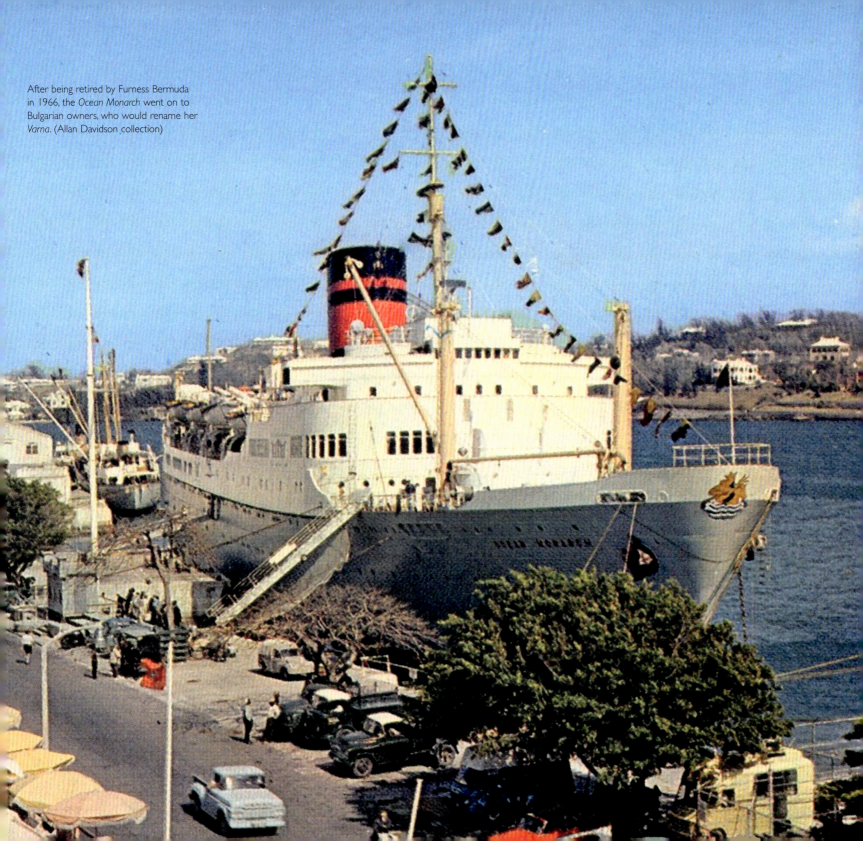

After being retired by Furness Bermuda in 1966, the *Ocean Monarch* went on to Bulgarian owners, who would rename her *Varna*. (Allan Davidson collection)

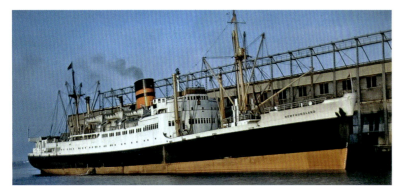

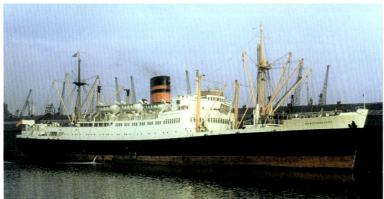

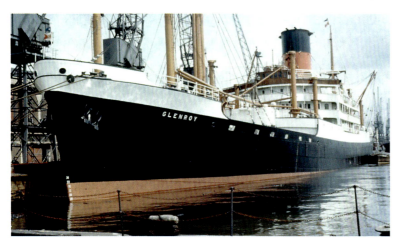

TOP TO BOTTOM: The *Newfoundland* and her sister offered leisurely crossings on the North Atlantic at a speed of 14–15 knots. (ALF collection); The *Newfoundland* and *Nova Scotia* were sold to Australian-based operators in 1962 and became the *Francis Drake* and *George Anson* respectively. (Mick Lindsay collection); The *Glenroy* and her sisters offered long, very leisurely voyages between the UK, northern Europe and the Far East. (Mick Lindsay collection)

Henderson Line

Prome and *Salween*

Part of the aforementioned Elder Dempster Lines, this Glasgow-based firm traded out east, primarily to Burma (modern Myanmar). Two passenger ships, the seventy-five-passenger sisters *Prome* and *Salween*, were used on the run between Liverpool, Port Said, Port Sudan, Aden, Colombo and Rangoon.

New Zealand Shipping Co. Ltd

Remuera
Rangitane, Rangitoto

Commonly known as NZCO, this line was a part of P&O's holdings and therefore used British registry. Five large combination passenger–cargo liners offered a regular service between London via Curaçao and the Panama Canal to Tahiti, Wellington and Auckland. On the return, passengers were landed at Southampton.

The company's newer ships were the 21,900-ton sister ships *Rangitane* and *Rangitoto*, which carried 416 one-class passengers each. They were added in 1949. Dave Smith recalled:

I sailed on the *Rangitane* for four months, from May 1960 until September. We sailed from the Victoria Docks, London and our route was sailed to Trinidad, Curaçao, through the Panama Canal, Tahiti, Fiji, Wellington and Auckland; the return passage was Auckland, Pitcairn Island, Fiji, Tahiti, Panama Canal, Curaçao, Trinidad, Southampton (to drop off the passengers) and then back to London to unload the cargo, which was mostly lamb, butter, etc. The roundtrip took 4 months. But for the final two hours, I had to travel all the way back to Southampton by train since they would not let the crew leave the ship in Southampton. I have a small flower holder that went on the dining room table with the New Zealand crest and engraved *MV Rangitane* and also a tea strainer with the crest engraved *MV Rangitoto*. They were lovely ships. My job on the *Rangitane* was to look after the Purser and the Chief Steward.

Great Bygone British Passenger Ships 55

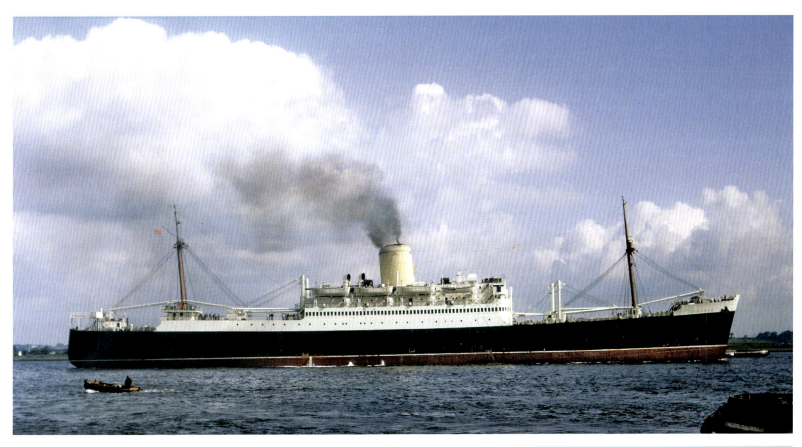

The *Remuera* – formerly the *Parthia* of Cunard – is seen passing Gravesend on a summer's day in 1964. (Kenneth Wrightman)

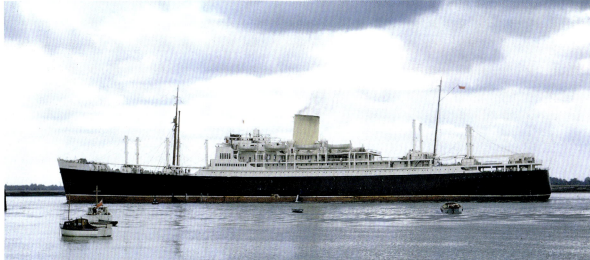

Among the very largest ships in the passenger–cargo category, the *Rangitane* – seen passing Gravesend – and its sister ship had very comfortable passenger accommodation that even included a small cinema. (Mick Lindsay collection)

56 British Passenger Liners in Colour

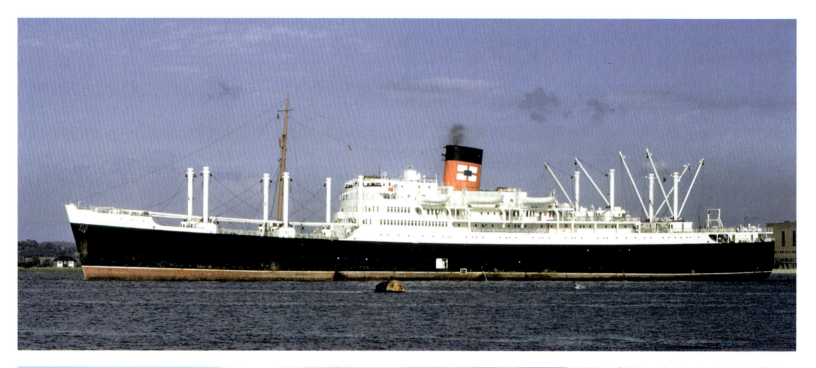

Slightly smaller than her sisters, the *Ruahine* is, as the photographer noted, 'seen in all her pomp as she moves inbound for The Royals [docks] in October 1966'. (Kenneth Wrightman)

The classic, twin-funnel *Rangitata*, dating from 1929, is seen in the Royal Albert Dock in a view dated 3 August 1958. (Kenneth Wrightman)

Ruahine, *Rangitiki* and *Rangitata*

A third, but slightly smaller version, the 17,900-ton *Ruahine*, carrying up to 267 passengers, was added in 1951. These ships were joined by two pre-war ships, the 1929-built sisters *Rangitiki* and *Rangitata*. These 16,900-ton ships remained two class, however: 123 in first and 288 in tourist class on the *Rangitata*, as an example.

P&O-Orient Lines

Himalaya, *Iberia* and *Arcadia*

Like Cunard, P&O is one of the greatest and most historic names in shipping. Dating from 1837, and again like Cunard, this company remains in business as part of the mighty Carnival Corporation. Today, they operate as many as eight passenger liners as P&O Cruises.

After the Second World War, P&O had to replace wartime losses and began building new liners: large, fast and well-appointed ships. This began with the 1,159-passenger *Himalaya* in 1949. The company's 'sensations' arrived in 1954 in the form of the 29,700-ton near-sisters *Iberia* and *Arcadia*. These ships joined the Orient Line passenger ships on the mainline run to Australia: London/Southampton, Gibraltar, Port Said, Aden, Bombay, Colombo, Fremantle, Melbourne and Sydney. After 1954, voyages sometimes continued to Auckland, Wellington, Fiji, Hawaii and then up to the North American west coast, to Vancouver, San Francisco and Los Angeles. Some voyages were routed to or from London/Southampton via Bermuda, Nassau, Kingston, the Panama Canal and Acapulco.

Passage through Suez was a memorable part of the four- to six-week voyages between the UK and Australia. It was the route of tens of thousands of 'ten-pound Poms' heading for new lives Down Under. (Michael Robertson collection)

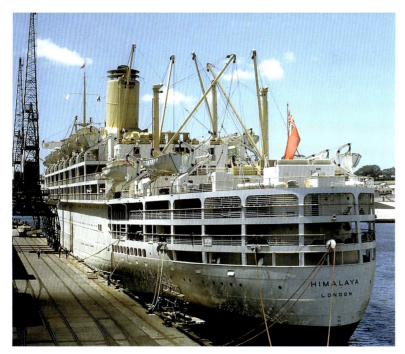

When completed in October 1949, the 27,955-ton, 22-knot *Himalaya* was the largest and fastest P&O liner. On her sea trials, she averaged well over 25 knots. (Frank Andrews collection)

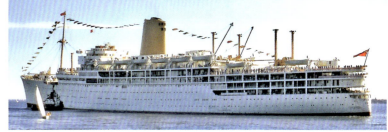

A near-sister to the *Arcadia*, the *Iberia* was a less-fortunate ship. Along with a long list of mechanical problems throughout her career, the ship was badly damaged in heavy weather off Ceylon (modern Sri Lanka) when rammed by an American tanker. The 721ft-long *Iberia* had an 80ft-long gash in her port side. (Tim Noble collection)

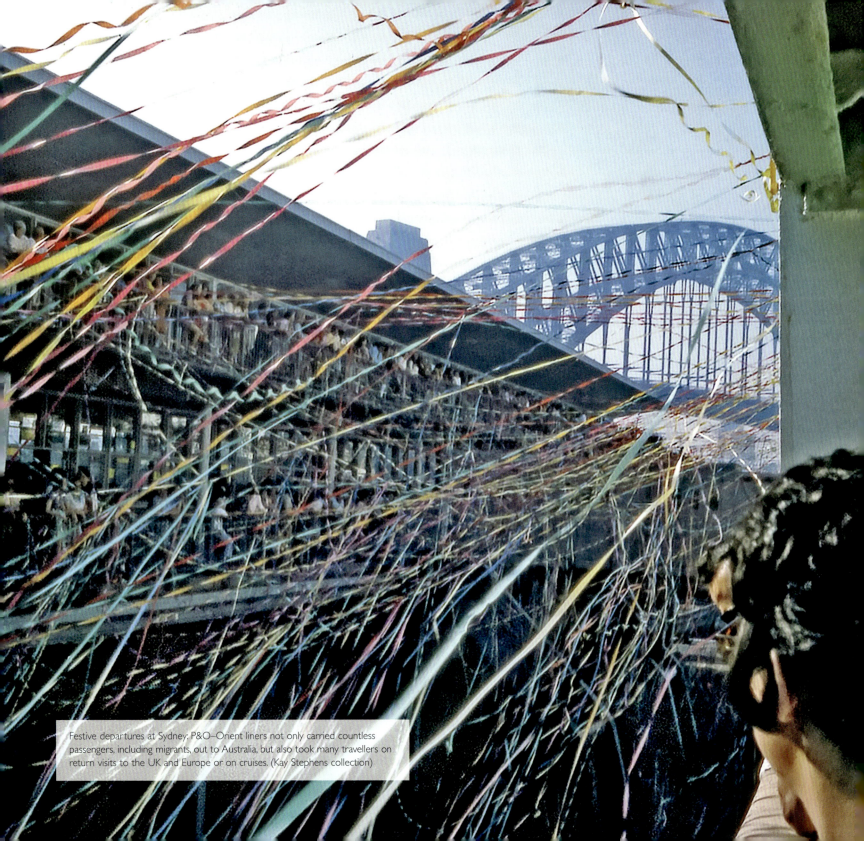

Festive departures at Sydney: P&O–Orient liners not only carried countless passengers, including migrants, out to Australia, but also took many travellers on return visits to the UK and Europe or on cruises. (Kay Stephens collection)

BELOW: The 1954-built *Arcadia* went on to become one of the most popular liners in the combined P&O–Orient fleet. Seen departing from Sydney's Circular Quay in February 1972, she cost a pricey £6.5 million when built. (Frank Andrews collection)

BOTTOM: In later years, before being retired in January 1979, the *Arcadia* became especially popular as a Sydney-based cruise ship. (Kay Stephens collection)

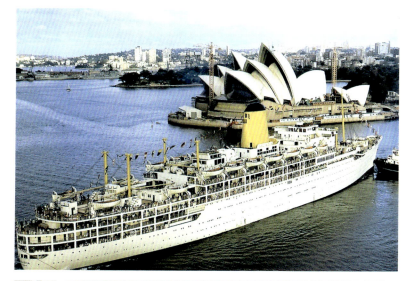

Strathnaver, *Strathaird*, *Strathmore* and *Stratheden*

Four of P&O's pre-war liners survived the war and resumed sailing, but only on the UK–Australia run. There were the sisters *Strathnaver* and *Strathaird* of 1931–32; the *Strathmore* of 1935; and, the largest of these, the 23,700-ton *Stratheden* of 1937.

Unlike the Orient Line, P&O also ran a passenger service to the Far East.

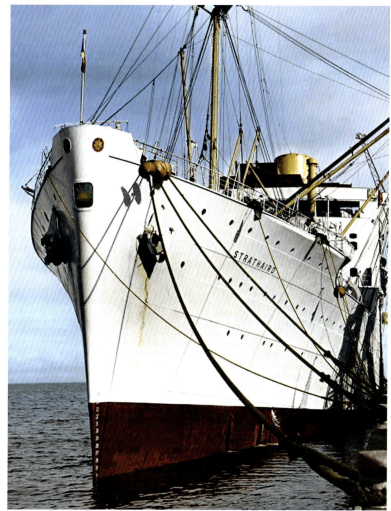

P&O had four post-war Strath liners – the *Strathnaver*, *Strathaird*, *Strathmore* and *Stratheden* – and each of them was later restyled for low-fare, all-one-class service. (Author's collection)

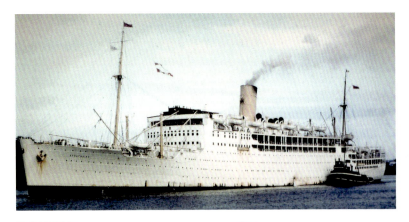
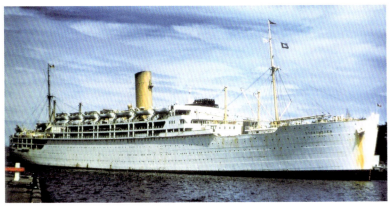

Orcades, Oronsay and Orsova

Closely linked with the P&O Lines, this London-based company was well known for its high-standard liners, its service to Australia, its cruises and carrying migrants. After war losses, the company added three large, well-appointed liners: the 1,545-passenger, 28,164-ton *Orcades* in 1948; the 1,416-passenger, 27,632-ton *Oronsay* in 1951; and the 1,503-passenger, 28,799-ton *Orsova* in 1955. They were routed on Orient's mainline service: London or Southampton to Gibraltar, sometimes Marseilles and/or Naples to Port Said, Aden, Colombo, Fremantle, Melbourne, Sydney and sometimes to Auckland and Wellington. Beginning in 1954, and in conjunction with P&O, these ships sometimes continued to Fiji, Hawaii and then the North American west coast (Vancouver, San Francisco and Los Angeles). Mostly in the summer, these ships also ran cruises to the Atlantic isles, Mediterranean and other places.

CLOCKWISE FROM TOP LEFT:
The *Strathaird* and her sister *Strathnaver*, dating from 1931–32, sailed for thirty years before going to Far Eastern scrappers in 1961–62. (David Williams collection); The *Strathmore* and *Stratheden* had second careers: they finished their days in Greek hands, mostly doing Muslim pilgrim voyages to Jeddah. (Mick Lindsay collection); As built, the *Orcades* was designed to carry 631 passengers in first class and 734 in lower-deck, less-expensive tourist class. (Tim Noble collection); Launched by Vickers-Armstrong at Barrow in October 1947, the 28,396-ton *Orcades* was the first of Orient Line's immediate post-Second World War rebuilding programme. (Tim Noble collection)

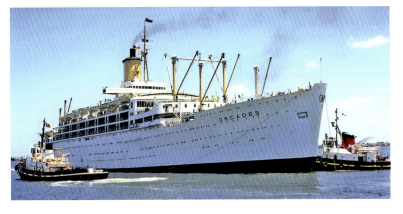

Great Bygone British Passenger Ships 61

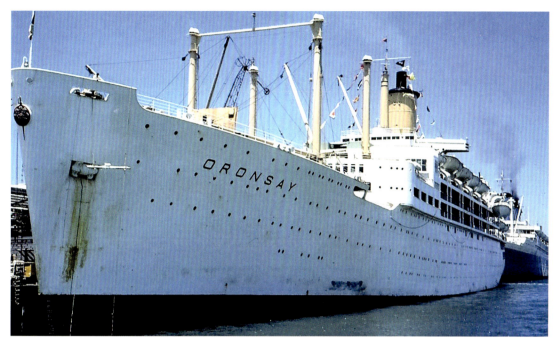

The *Oronsay* – completed in 1951 and seen here at Melbourne – made P&O–Orient's first joint service voyage to the North American West Coast in 1954. The two companies soon branched out to worldwide passenger operations. (Tim Noble collection)

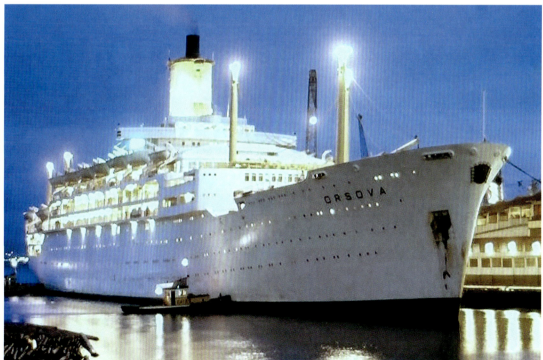

When introduced in May 1954, the *Orsova*'s design looked to the future. She was the first large liner to dispense with the conventional mast. (Tim Noble collection)

62 British Passenger Liners in Colour

Voyages on P&O–Orient Lines were advertised as 'touching all the seven seas' – and could be as short as two or three days or as long as three or four months. The aft decks on the *Orsova* are seen here during a Sydney–Vancouver voyage. (Tim Noble collection)

Otranto, Orontes, Orion and *Oriana*

Several pre-war liners continued in post-war service, namely the *Otranto, Orontes* and *Orion*. They were used on the same UK–Australia trade but, as they aged, they were primarily used for one-class migrant and low-fare service.

Robert Bishop remembered:

I grew up near the London Docks and was raised by my mother, my grandmother and an aunt. My father seemed always to be away, to be at sea. He worked for the Orient Line for 35 years and sailed on such liners as the *Orontes, Oronsay, Orsova* and *Oriana*.

Esme Prestwick recalled:

The cruises themselves on P&O were great, colorful, exciting adventures. I remember ports such as Lisbon, Madeira, Barcelona, Ibiza, Naples, Athens and Venice. We also went north on occasion – to Norway and the fjords, Copenhagen and Stockholm. We cruised in the *Chusan, Orcades, Himalaya, Oronsay, Orsova* and *Arcadia*. Each ship had a slightly different onboard personality, something you liked or remembered especially about each. But they were each wonderful in their time. And I remember they smelled of soap – a very fresh, very clean smell.

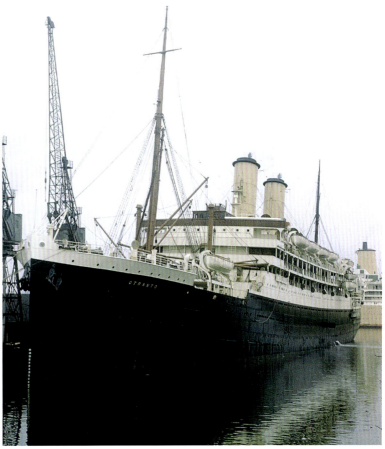

ABOVE: Older P&O–Orient Lines ships, such as the *Otranto* of 1925 (seen berthed in London), were used primarily for the low-fare, migrant service between the UK and Australia in the 1950s and '60s. (Mick Lindsay collection)

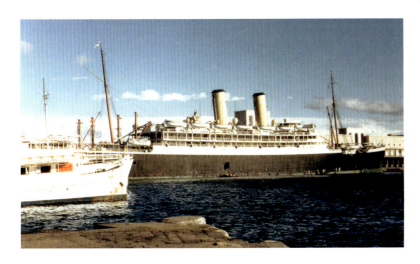

LEFT: Another veteran was the 20,000-ton *Orontes*, seen berthed at Naples en route to Australia, and which was restyled to carry 1,370 one-class passengers. (Author's collection)

64 British Passenger Liners in Colour

Seen here outward bound from Sydney, the *Orontes* had six passenger decks. (Tim Noble collection)

Great Bygone British Passenger Ships 65

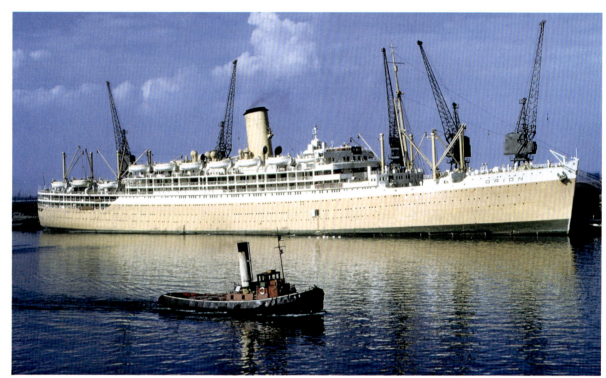

CLOCKWISE FROM RIGHT:
The *Orion* of 1935 was another liner that spent her final years in primarily migrant and low-fare service. Seen here in London Docks, she cost comparatively little to build at less than £1 million. (Mick Lindsay collection); A fun-filled, leisurely afternoon on board the *Orion* in the 1950s. (Tim Noble collection); In the end, in 1963, before it passed to Belgian scrappers, the *Orion* was used as a moored hotel ship at Hamburg. (Mick Lindsay collection)

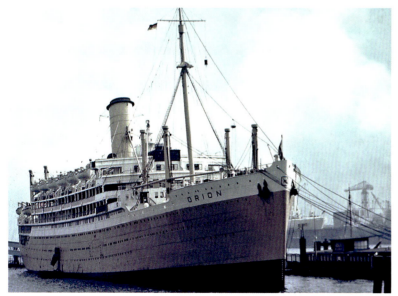

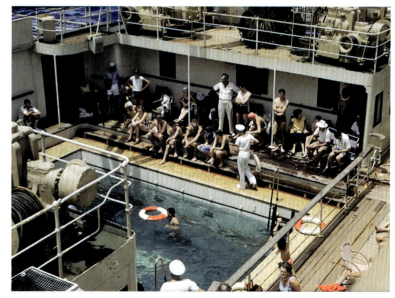

66　British Passenger Liners in Colour

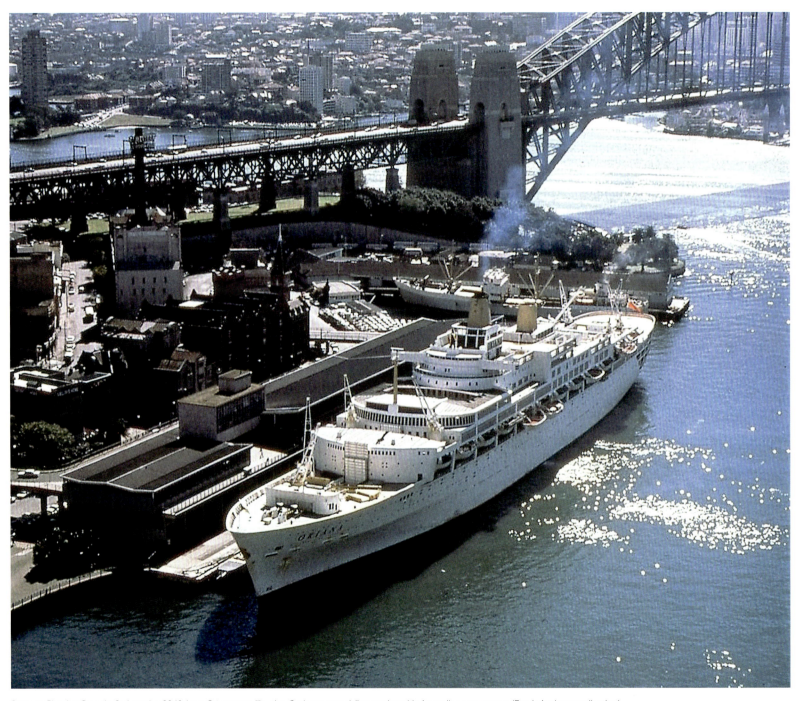

Seen at Circular Quay in Sydney, the 804ft-long *Oriana* was, like the *Canberra*, especially popular with Australian passengers. (Frank Andrews collection)

Great Bygone British Passenger Ships 67

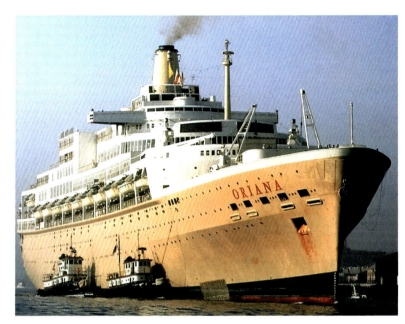

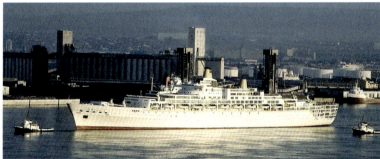

CLOCKWISE FROM TOP LEFT: The *Oriana*, introduced in late 1960, ranked as the fastest liner to Australia: twenty-one days from Southampton via Suez to Sydney. The previous record was twenty-eight days. (Author's collection); The forward funnel on the 41,923-ton *Oriana* was a working stack; the aft, lower funnel served as an engine room vent. (Tim Noble collection); The *Oriana* was transferred to P&O Cruises in 1973 and thereafter made mostly cruise voyages. With a capacity listed at 1,700 all-one class, the ship is seen here arriving at Quebec City during a transatlantic cruise to North America. (Author's collection)

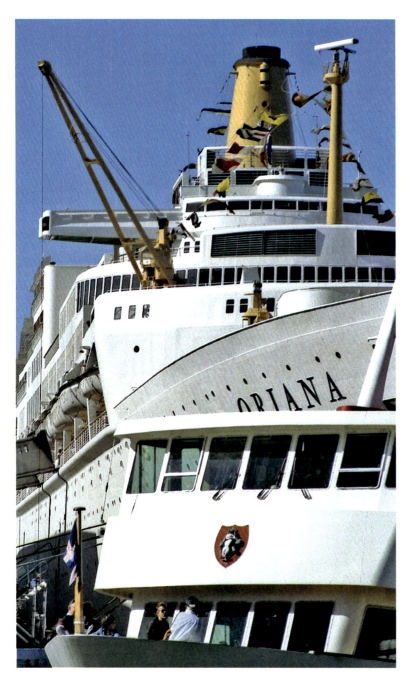

Retired from P&O service in 1986, the *Oriana* was sold to Japanese and then Chinese owners for use as a floating museum, hotel and entertainment centre. Heavily damaged by a typhoon in June 2004, she was broken up in China a year later. (Tim Noble collection)

Canberra

Esme Prestwick has been a loyal passenger to P&O and commented:

We later moved over to the bigger *Oriana* and *Canberra* from earlier P&O ships. They were much more spacious, had greater outdoor decks and were more modern in décor. They were quite different, of course, but I can't say I liked one over the other. Both had their loyal fans. I was on the *Canberra* in 1997, her final season. It was sad to see her go – and in ways the old P&O Company went with her. Things were changing – and quickly – to the likes of the new *Oriana* and *Aurora* – and these days to the gigantic *Iona*.

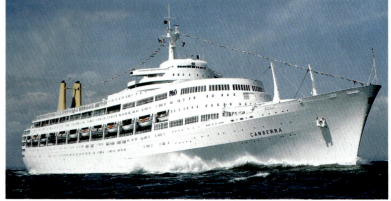

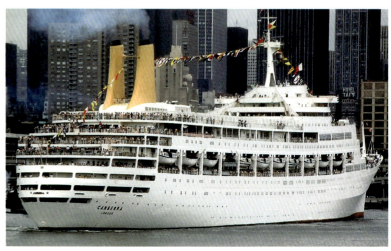

RIGHT: The *Canberra* was transferred to P&O Cruises in 1973 and assigned mostly to cruise service. (Author's collection)

LEFT TOP: When completed in June 1961, the 44,000-ton *Canberra* ranked as the largest vessel built in the UK since the *Queen Elizabeth* in 1940. Also ranking as the largest liner ever for UK–Australia service, the 818ft-long liner cost a hefty £15 million. (Mick Lindsay collection)

LEFT BOTTOM: Seen departing from New York during a cruise in June 1979, the *Canberra* was originally designed with adjustable accommodation – 556 or 596 in first and 1,716 or 1,616 in tourist class. (Author's collection)

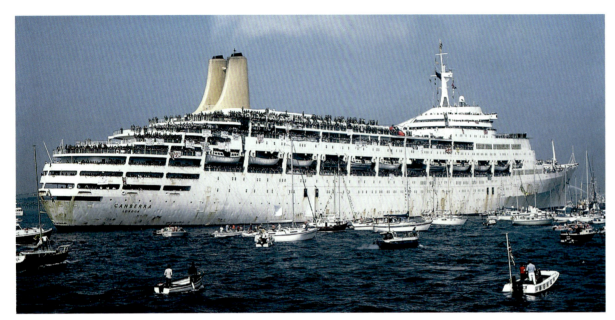

In April 1982, the *Canberra* sailed from Southampton to the Falklands as a troopship. She returned home three months later, on 11 July, to a heroic welcome. (Author's collection)

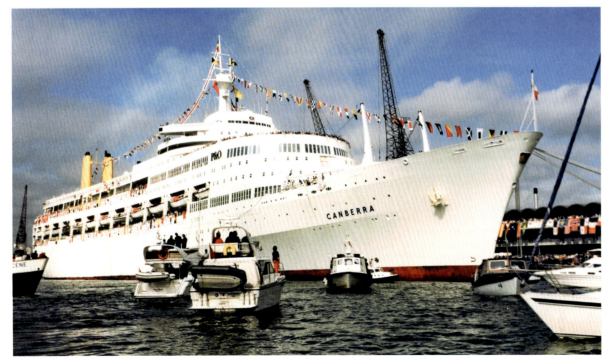

In September 1997, the *Canberra* completed her final P&O voyage and a month later was beached at Gadani Beach in Pakistan for scrapping. (Author's collection)

Chusan, *Canton*, *Corfu* and *Carthage*

After the Second World War, P&O reinforced its Far East passenger service with a new, large liner: the 24,215-ton, 1,026-passenger *Chusan* in 1950. She joined the 16,000-ton *Canton* of 1939 and the sister ships *Corfu* and *Carthage*, which dated from 1931. These ships were routed London/Southampton, Port Said, Aden, Bombay, Colombo, Penang, Singapore, Hong Kong, Kobe and Yokohama.

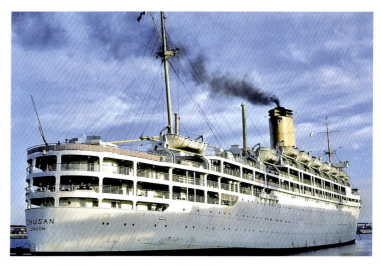

ABOVE: At 24,200 tons and carrying nearly 1,000 passengers, the *Chusan* entered service in June 1950. At the time, she was not only the largest, but also the fastest and finest P&O liner on their alternate UK–Far East service. (Tim Noble collection)

LEFT: Used on the London–Far East route, the 1938-built *Canton* could carry six holds of cargo along with 298 first- and 244 tourist-class passengers. (Mick Lindsay collection)

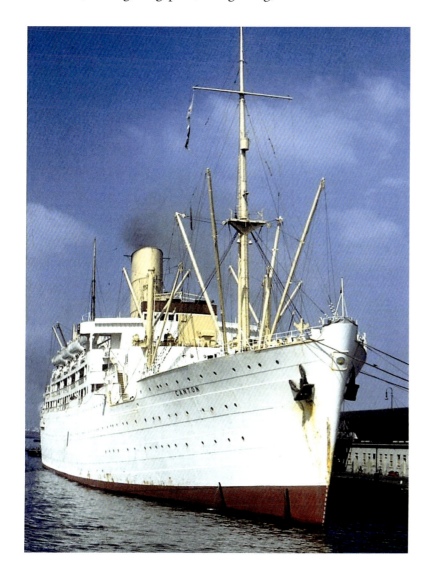

Cathay and *Chitral*

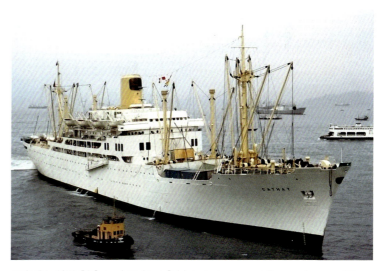

ABOVE: In 1961, P&O purchased two Belgian passenger–cargo liners and renamed them as *Cathay* (seen here at Hong Kong) and *Chitral* for the final years of the once traditional London–Far East service. (ALF collection)

72 British Passenger Liners in Colour

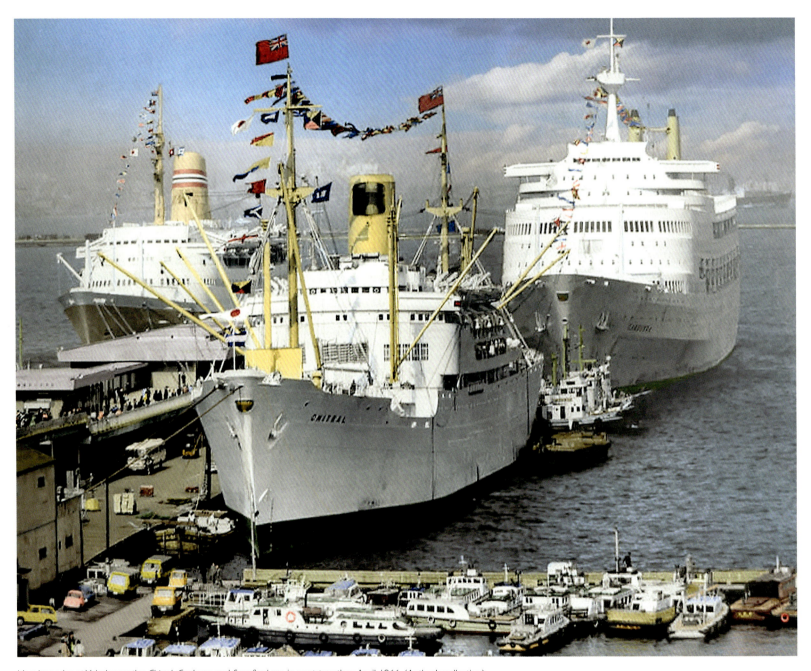

It's a busy day at Yokohama: the *Chitral*, *Canberra* and *Sagafjord* are in port together, April 1966. (Author's collection)

Great Bygone British Passenger Ships 73

Empire Fowey

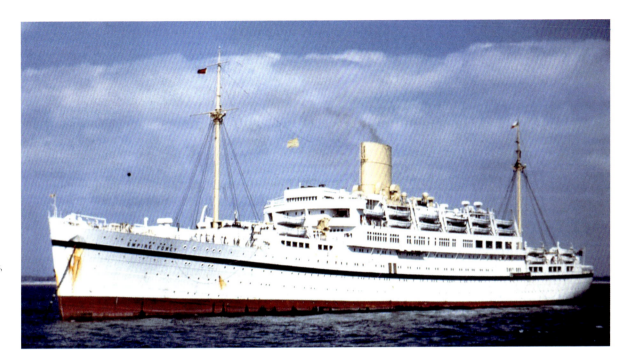

P&O, like several other British shipowners, managed peacetime troopships on behalf of the Ministry of Transport. The *Empire Fowey* had been the 1935 German-built *Potsdam*, seized after the war and then refitted for over 1,600 passengers and troops. (David Williams collection)

Pacific Steam Navigation Co.

Reina del Pacifico and *Reina del Mar*

Commonly known as 'PSNC', this British company serviced the Caribbean and South America, but to the west coast only. Two liners were used: the 1931-built *Reina del Pacifico* and then the 20,234-ton, three-class *Reina del Mar*. Their routing was port-intensive: Liverpool, La Rochelle, Santander and Corunna (modern A Coruña) and then across to Bermuda, Nassau, Havana, Kingston, La Guaira, Curaçao, Cartagena, Cristóbal, La Libertad, Callao, Arica, Antofagasta and Valparaíso. The round voyage took two months.

Michael Stephen Peters, who went on to become chief engineer of the *Reina del Mar*, recalled, 'When I joined Pacific Steam Navigation Company, they were just retiring the 28-year-old *Reina Del Pacifico*, the predecessor to the new *Reina Del Mar*. She was having engine troubles in those final days and was operating on three and a half instead of four engines.'

Peters joined the 20-knot *Reina del Mar* in 1960–61 and had fond memories of that all-white liner that was topped off by a single, tapered, all-yellow funnel:

We were still doing 5 line voyages a year, sailing from Liverpool and then via La Rochelle, Santander and Vigo before crossing to Bermuda, Nassau, Kingston, Cartagena, the Panama Canal and then West Coast

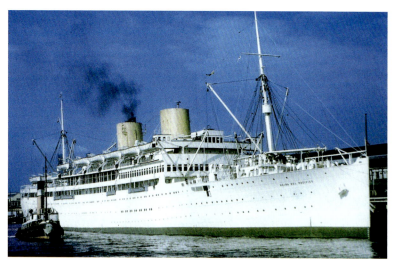

Completed in 1931, the *Reina del Pacifico* was quite popular on the Liverpool–Caribbean–South American west coast run. (Mick Lindsay collection)

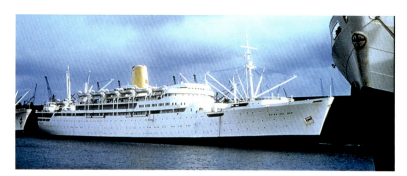

Completed in 1956, the larger *Reina del Mar* saw only a few years in traditional South American service before she was surpassed by airline competition. The 20,200grt ship would then join Union-Castle Line and became a popular cruise ship. (Mick Lindsay collection)

of South America ports such as Guayaquil, Callao and Valparaiso. She was a good sea boat, but you needed to understand her. Like all ships, she had her moods. For passengers, we had mostly businessmen in first class and who turned the long voyage into their holiday. We carried mostly immigrants in third class, usually from French and Spanish ports, going to South America. In January, we often had passengers who took the 10-week round voyage as a complete cruise. It was an escape from the dreary British winters. We included ports such as Tenerife, Madeira, Barbados and Curaçao on these voyages.

Like most passenger liners of that period, the *Reina del Mar* also carried cargo as well. Peters added:

> Cargo was good for extra revenue as well as ballast. We took mostly manufactured goods from Liverpool as well as specialty food items, which were destined for hotels in the Caribbean and South America. On the homeward trips, we carried tin ore and Bolivian copper as well as fish meal and cotton.

The airlines were merciless in their competitive battle with traditional passenger ship companies like PSNC. Peters noted:

> It was the sudden lack of passengers that killed the *Reina del Mar*. Her demise on the South American run came quickly, in fact very quickly. Corporate thinking had changed and executives as well as staff members could now do a one-day flight instead of a 5- of 6-week voyage. And the cargo we carried was better suited to freighters. The *Reina del Mar* was quite empty in the end, carrying less than 50% of her capacity on some voyages. We experimented with one Mediterranean cruise, but cruising was not in Pacific Steam's thinking. She was soon chartered and then sold outright to the Union-Castle Line for fulltime cruising. In between, she also did some cruising for TSA, the Travel Savings Association, a bargain operation that made cruises a sort of interest on banking. I recall that, in 1964, the *Reina del Mar* was sent over to New York for the World's Fair. The two-week trips under TSA cost as little as 60 pounds [approx $275].

The Travel Savings Association was formed by Max Wilson, a South African entrepreneur, in early 1963. He created a kind of banking plan: people would make planned and timed payments towards their holiday at sea while earning interest and bonuses. Advertising in the UK was very strong at first. In due course, Canadian Pacific Steamships had a 50 per cent share in this firm while Union-Castle took 25 per cent and Royal Mail Lines the final 25 per cent. Canadian Pacific soon chartered the *Empress of Britain* for cruising from British ports, the *Empress of England* for wintertime cruises from South Africa, and then the *Reina del Mar*. Many British-flag liners were beginning to struggle in their earlier, traditional services and so TSA seemed the ideal alternate.

Indeed, over 9,000 passengers were booked by mid-1963. It was all very promising, so promising that the three-class *Reina del Mar* was converted to a full-time, all-one-class cruise ship in 1964. It was reported that TSA would actually buy her and then run her in conjunction with the Chandris Lines' management, then an up-and-coming Greek passenger company.

In the end, however, the TSA failed. Union-Castle promptly took all the shares and inherited the charter of the *Reina del Mar* from PSNC (and then technically changed to Royal Mail Lines). Union-Castle re-chartered her from 1969 onwards (until they finally bought her outright in 1973).

'The TSA was shortlived. It was never as popular in Britain as it was in South Africa,' recalled former purser John Dimmock. 'In the end, the Company had high expenses, especially for advertising, and that left them over-extended.'

Royal Mail Lines

Andes and *Alcantara*

Another division of Furness, Withy and Company, this London-based firm had a long history serving South America. But differing from PSNC, Royal Mail's interests were on the east coast of South America.

Two big liners, the 26,900-ton *Andes* and the 22,500-ton *Alcantara*, maintained the luxury service: Southampton via Cherbourg, Vigo, Lisbon and Las Palmas to Rio de Janeiro, Santos, Montevideo and Buenos Aires. The run from Southampton to Buenos Aires took twenty-one days. Each carried passengers in two classes.

Asturias

Following military service during the Second World War, the *Asturias* was not restored for regular passenger service.

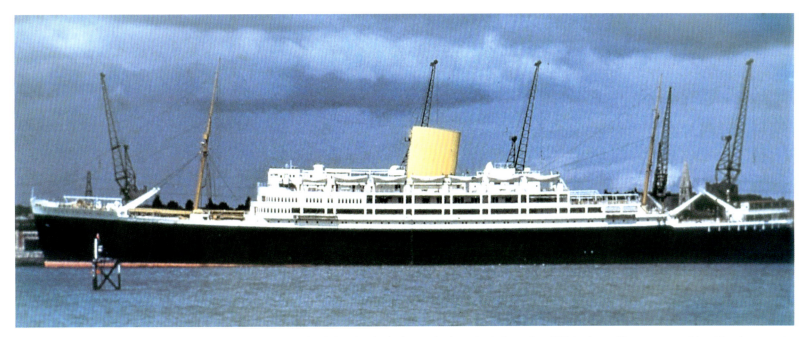

The largest and most luxurious British liner ever created for service to South America, the *Andes* was due in service in September 1939, but her maiden voyage was delayed for nine years due to the sudden outbreak of war. (David Hutchings collection)

CLOCKWISE FROM RIGHT: In 1959, the *Andes* was converted for full-time cruising and given 500 all-first-class berths, coupled with superb service and changing itineraries. She was one of Britain's most popular liners of the 1960s. (David Williams collection); Meeting in Capetown: the *Andes* on the left, and the Swedish liner *Kungsholm* on the right. (Vincent Messina collection); Sister ship to the *Asturias*, the *Alcantara* was returned to the three-class liner service from Southampton to the east coast of South America. (David Williams collection)

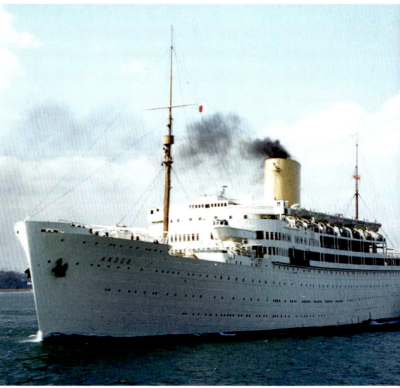

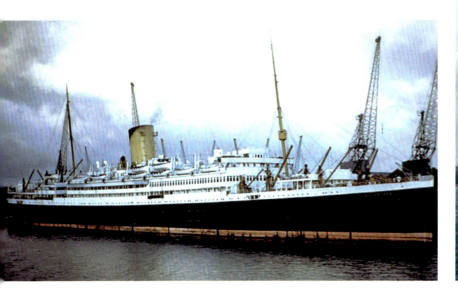

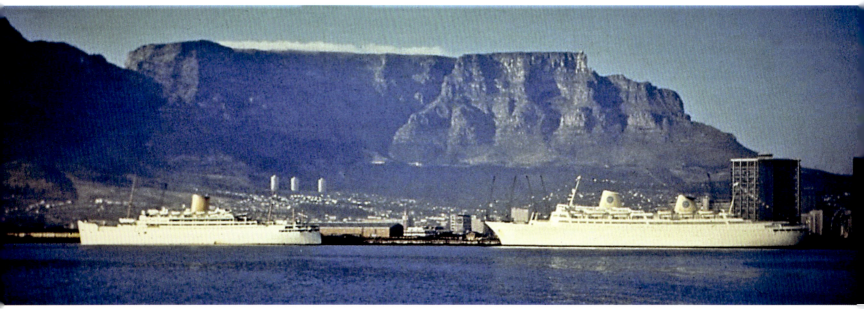

Great Bygone British Passenger Ships 77

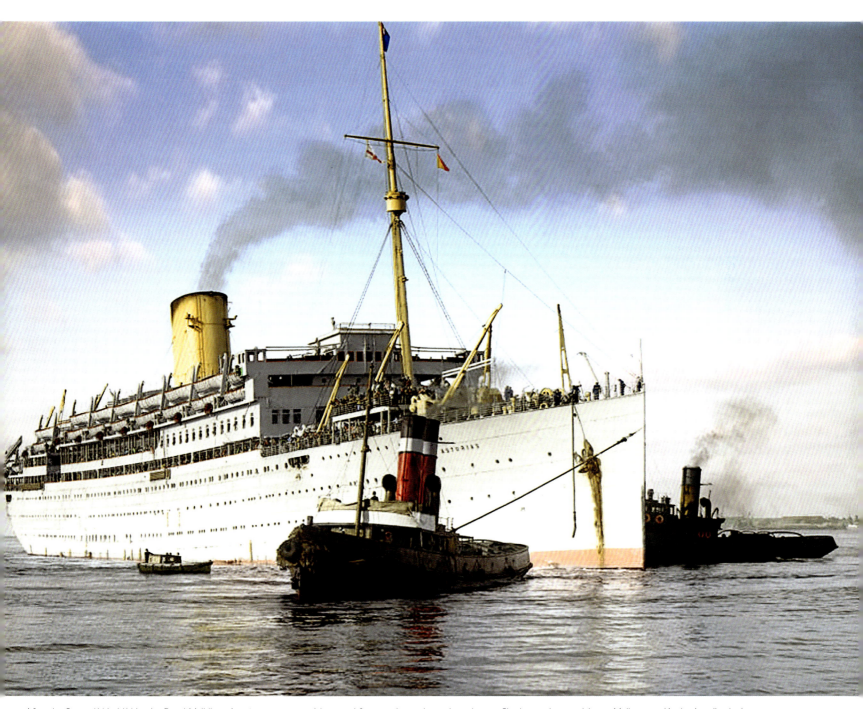

After the Second World War, the Royal Mail liner *Asturias* was restored, but used for trooping and carrying migrants. She is seen here arriving at Melbourne. (Author's collection)

Highland Brigade, *Highland Princess*, *Highland Monarch* and *Highland Chieftain*

From London, there were the four sisters of the Highland class: the *Highland Brigade*, *Highland Princess*, *Highland Monarch* and *Highland Chieftain*, which sailed from London and Cherbourg to Vigo, Lisbon, Las Palmas, Rio de Janeiro, Santos, Montevideo and Buenos Aires. Passage time from London to Buenos Aires took three weeks.

Amazon, *Aragon* and *Arlanza*

Beginning in 1959, the Highland ships, dating from 1929–30, were replaced by three, 20,300-ton combo-type ships: the 493-passenger *Amazon*, *Aragon* and *Arlanza*. They would be Britain's final three-class passenger ships and the last to offer third-class quarters.

Bob Cummins began on Royal Mail Lines freighters, but soon transferred to the firm's affiliate passenger ship division. He was assigned to their 20,300-ton *Amazon*:

> Then a brand new beauty, she had the finest first class restaurant I've ever seen and which sat all of 100 or so of the first class passengers at a single seating. We'd have older English diplomats, the Argentine land barons and aristocracy, wealthy British tourists and some well-heeled wintertime round-trippers. There was also a second class with 82 berths and 275 in third class, but which was primarily for Spanish and Portuguese immigrants bound for South America. They would board at Vigo and at Lisbon. We trained the British passengers down to the Tilbury Landing Stage from London (after a 10-day stay for cargo handling in the Royal Docks) and then had a short tender call at Boulogne. In South America, we called at Rio, Santos, Montevideo and then offloaded all final passengers at Buenos Aires. The ship was then moved, for five days, to La Plata to load Argentine beef. We would then return to Buenos Aires, take on passengers and then sail in reverse homeward to the UK. Unfortunately, British industrial problems killed these ships. Often, we would return to South America with half the cargo we brought up because of some dockers' dispute on the London Docks. Three-class ships with sizeable freezer cargo spaces and in the increasingly cost-sensitive Sixties, these three liners never quite made it. Even later, in less than ten years, when they transferred over to Shaw Savill [the *Amazon* became the *Akaroa*], they were equally unsuccessful.

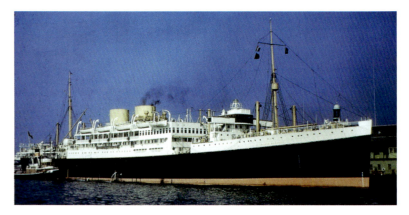

After Second World War duties, the stately looking *Highland Monarch* and her sisters were returned to the South American passenger run from London. (Mick Lindsay collection)

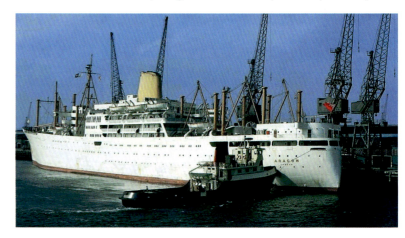

In the final era of passenger ship service between the UK and South America, Royal Mail added three sister ships – the *Amazon*, *Aragon* and *Arlanza* (seen at London) – in 1959–60. They were noted as the last three-class ships under the British flag. (Mick Lindsay collection)

Shaw Savill Line

Dominion Monarch

Officially known as Shaw, Savill and Albion Co. Ltd, this London-headquartered firm had something of an eclectic fleet. The 1939-built *Dominion Monarch* operated independently on an extended service to Australia and New Zealand: three and a half months' roundtrip from London and Southampton to Las Palmas, Cape Town, Fremantle, Melbourne, Sydney and Wellington.

Great Bygone British Passenger Ships 79

Completed just before the Second World War began in 1939, the 26,500-ton *Dominion Monarch* was considered by many to be Shaw Savill's finest liner. All-first class, she carried just over 500 passengers. (Mick Lindsay collection)

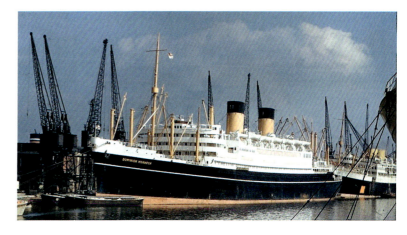

Roundtrips from London and Southampton out to Australia and New Zealand and via South Africa took three and a half months on board the *Dominion Monarch*. (David Williams collection)

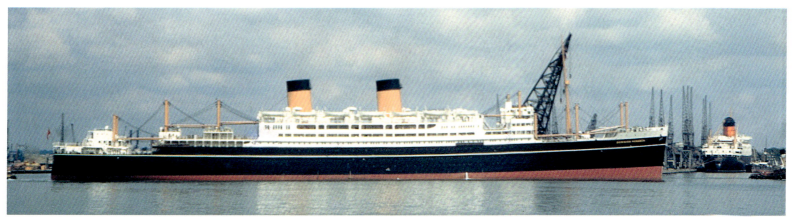

This large passenger–cargo liner (26,463 tons) carried only 508 all-first-class passengers. To some, she was one of the finest liners ever to serve Australia.

Geoff Stewart, a former steward, was quite proud: 'She was a gorgeous old ship, done in very traditional style. One room had a full display of armor and swords.' He made the last three voyages aboard the *Dominion Monarch*.

Southern Cross and *Northern Star*

Far different from the *Dominion Monarch*, Shaw Savill added the innovative *Southern Cross* in 1955. At 20,200 tons, she carried 1,100 passengers, all in tourist class. Her engines and funnel were placed aft and she had no provision for cargo, but made only continuous around-the-world voyages. Her itinerary read: Southampton, Trinidad, Curaçao, Panama Canal, Tahiti, Fiji, Wellington, Sydney, Melbourne, Fremantle, Durban, Cape Town, Las Palmas and return to Southampton. Bookings were offered for short overnight voyages, trips to Australia and as full world cruises. The 20-knot *Southern Cross* was one of the most unique ships of the 1950s and was followed, in 1961, by the slightly larger *Northern Star*.

80 British Passenger Liners in Colour

RIGHT: The *Southern Cross* later became a cruise ship named *Calypso*, *Azure Seas* (seen here at Los Angeles) and *Ocean Breeze*. (Author's collection)

BELOW: This outstanding and trendsetting ship was launched by HM Queen Elizabeth II in August 1954. The 604ft-long *Southern Cross* was the first large liner to have her engines and, therefore, funnel placed aft. (Mick Lindsay collection)

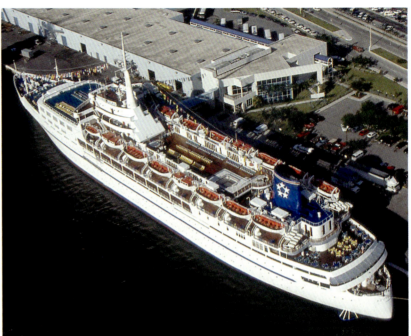

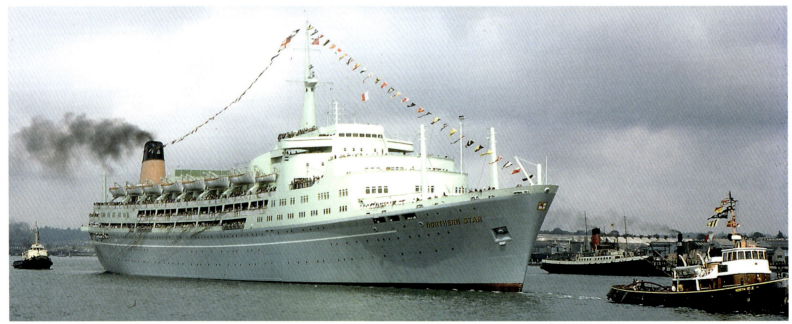

An improved, slightly larger version of the *Southern Cross*, the *Northern Star* was completed in 1962. She is seen departing from Southampton on her maiden voyage, beginning a three-and-a-half-month trip around the world. (David Williams collection)

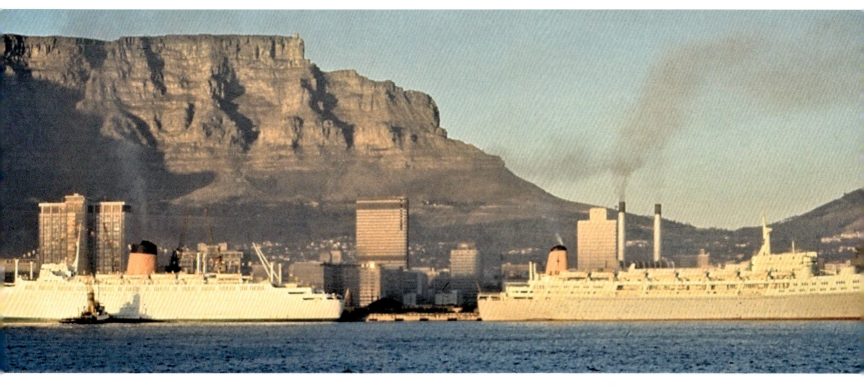

The *Northern Star* (right) meets another Shaw Savill liner, the *Ocean Monarch* (ex-*Empress of England*), at Cape Town. (Vincent Messina collection)

Mataroa and *Tamaroa*
Athenic, *Ceramic*, *Corinthic* and *Gothic*

There were several older, pre-war passenger ships, such as the *Mataroa* and *Tamaroa*, on the London–Panama–New Zealand run. After the war, in 1947–48, Shaw Savill added four large combo ships – the *Athenic*, *Ceramic*, *Corinthic* and *Gothic* – that were nearly 16,000 tons but which carried only eighty-five all-first-class passengers. They too were employed on the New Zealand run: London via Curaçao and Panama to Auckland, Wellington and other New Zealand ports according to cargo demands.

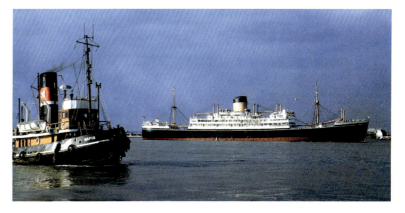

The combination passenger–cargo liner *Gothic* was, as the photographer noted, 'looking immaculate as she steams past Gravesend'. (Kenneth Wrightman collection)

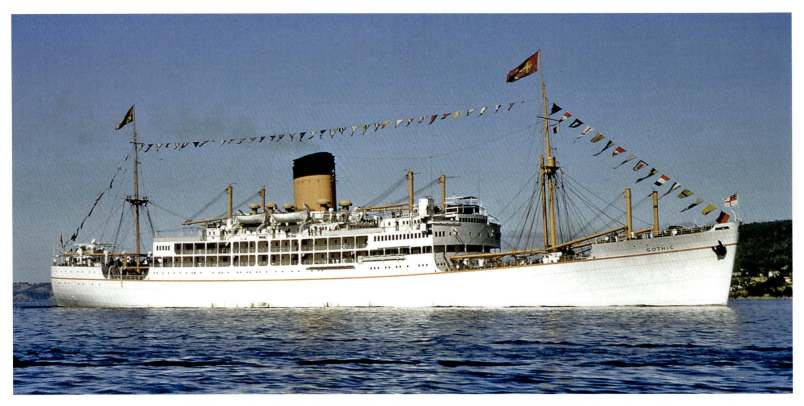

Arriving at Hobart, Tasmania, in early 1954, the *Gothic* served as a royal yacht for Queen Elizabeth II and the Duke of Edinburgh. (Tim Noble collection)

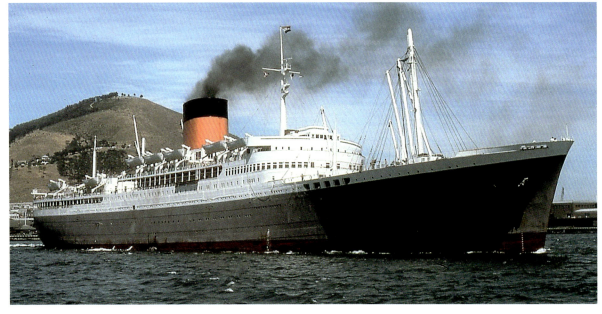

Completed in 1948, the sister ships *Edinburgh Castle* (seen here) and *Pretoria Castle* were considered Union-Castle's 'post-war sensations'. (Mick Lindsay collection)

Union-Castle Line

Pretoria Castle, Edinburgh Castle, Capetown Castle, Stirling Castle, Athlone Castle, Carnarvon Castle, Winchester Castle and *Arundel Castle*

Another of Britain's great passenger lines, Union-Castle had a long history in service to Africa. To many, it was the most important company in that trade, and their 'Cape Mail Express' was one of the great and most popular sea routes.

Service between Southampton via Madeira or Las Palmas and Cape Town, Port Elizabeth, East London and Durban took thirteen days in each direction and required (for weekly service) eight liners. In 1958, these included the 28,705-ton sisters *Pretoria Castle* and *Edinburgh Castle* (which carried up to 755 passengers in first- and tourist-class accommodation) and the pre-war-built *Capetown Castle*, *Stirling Castle*, *Athlone Castle*, *Carnarvon Caste*, *Winchester Castle* and, oldest of all, the 1921-built *Arundel Castle*. These ships were also noted for their lavender-coloured hulls.

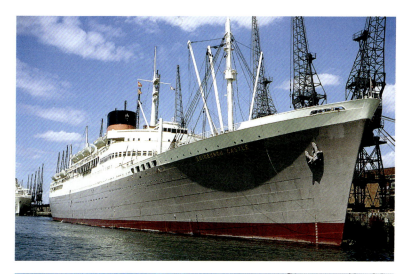

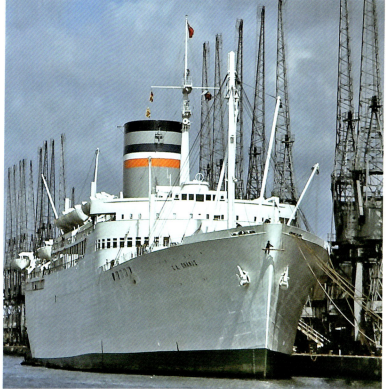

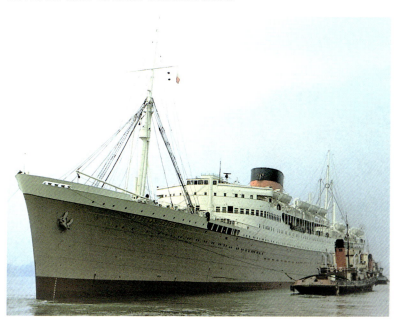

CLOCKWISE FROM TOP RIGHT: The 747ft-long *Edinburgh Castle* had been named by Princess Margaret. (Mick Lindsay collection); The *Pretoria Castle* was also transferred to the South African Marine Corporation in 1966 and was renamed *S.A. Oranje*. The ship was transferred to South African registry three years later. (David Williams collection); The *Capetown Castle*, added in 1938, was the first Union-Castle liner not to be named after a location in the British Isles. (Mick Lindsay collection)

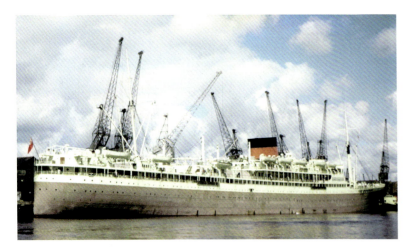
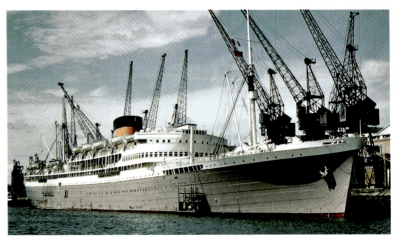
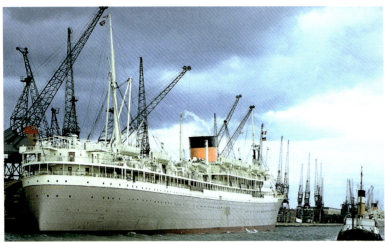
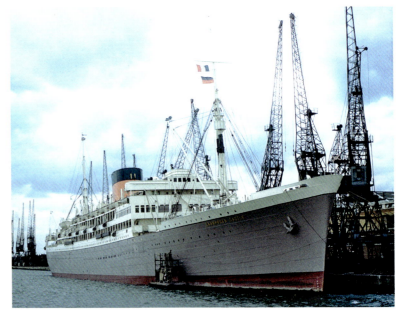
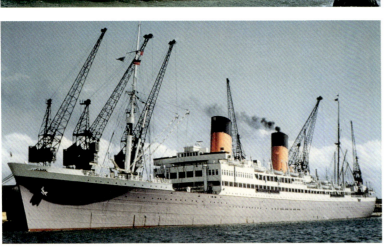

CLOCKWISE FROM TOP LEFT: The sisters *Stirling Castle* (seen at Southampton) and *Athlone Castle* were considered two of the most handsome-looking liners of the 1930s. They were said to be 'long, sleek and well proportioned'. (Mick Lindsay collection); Along with lots of cargo, the *Stirling Castle* could carry 245 first- and 538 tourist-class passengers. (Mick Lindsay collection); Completed in 1926, the 584-passenger *Carnarvon Castle* had been built originally with two squat funnels. The ship was rebuilt in 1938. (Mick Lindsay collection); Built in 1915–21, the 19,000-ton *Arundel Castle* and her sister, the *Windsor Castle*, were the only four-stackers built for a service other than the North Atlantic. Rebuilt in 1937 with two funnels, the *Arundel Castle* was finally scrapped in 1959. (David Williams collection); The *Athlone Castle* was named in November 1935 by Princess Alice, the Countess of Athlone, who was a frequent passenger in later years. (Mick Lindsay collection)

Pendennis Castle and *Windsor Castle*

A replacement program of three new, improved, even faster liners was begun in 1959 with the 28,582grt, 22-knot *Pendennis Castle*. She replaced the aged *Arundel Castle* in late 1958.

John Dimmock served for thirteen years as purser on board the Union-Castle's flagship and largest liner, and during the final years of the famed 'Cape Mail Express':

> The *Windsor Castle* and the *Pendennis Castle* were our most favored big ships. We had regular passengers who came year after year – and would only sail on these two ships. It was much like a large club, a sea-going club. I especially remember one sailing wherein every first class passenger was titled. They all knew one another from previous trips and entered completely into the spirit of the voyage. These passengers would, like so many others, catch the first sailing of the New Year and later would transfer from the first class main lounge in the *Windsor* or the *Pendennis* to the main lounge of the Mount Nelson Hotel in Cape Town, which was, by the way, then owned by Union-Castle.

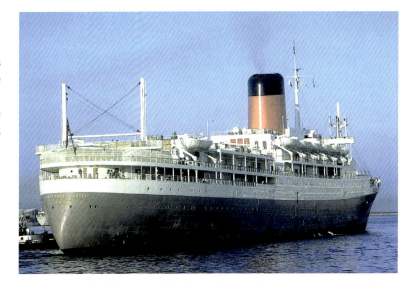

When completed in 1958, the sleek, 27,600-ton *Pendennis Castle* represented a new style of South African mailship. Even her contemporary interior decor was considered a noted change. (Mick Lindsay collection)

The 763ft-long *Pendennis Castle* could carry 197 first- and 473 tourist-class passengers. (Luis Miguel Correia collection)

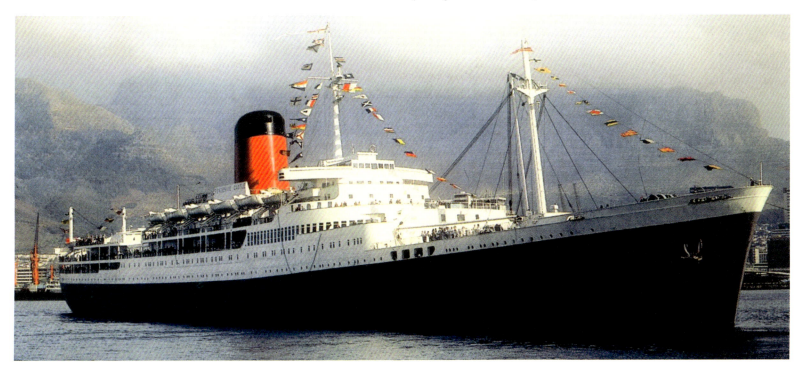

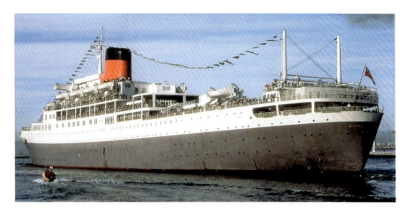

The largest and fastest liner of all for the South African run, the *Windsor Castle* – launched in June 1959 – was also the largest liner to be built on Merseyside, at Birkenhead. Named by the Queen Mother, she was an instant favourite with Union-Castle travellers. (Mick Lindsay collection)

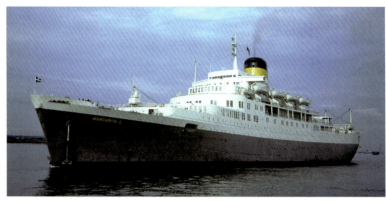

When the South African liner service closed down in the autumn of 1977, the *Windsor Castle* sailed off to new Greek owners as the renamed *Margarita L* and to a second career as an accommodation ship for Middle Eastern refinery workers. (David Hutchings collection)

Having escaped the dreary British winter, these passengers were affectionately known as 'winter dodgers'. They would return on a northbound sailing in April or May. Each year, we would rotate the first sailing in January between the *Windsor Castle* and the *Pendennis Castle*.

Former officer Peter Rushton recalled:

We carried lots of businessmen and government officials to and from almost all the African countries. Some businessmen had meetings onboard the ships. One corporate leader used to charter a whole mailship for a sort of 'booze cruise' going north to England. We had a good share of holiday-makers by the 1960s, especially older people going off on garden tours in South Africa or wanting long stays in the sun at seaside resorts. We had some British migrants by the 1960s, but Australia was always the far bigger lure. All of the mail ships carried lots of cargo as well. We would have general manufactured goods going south and this included crated automobiles. On the northbound trips, we carried skins, hides, nuts, gold bullion and the mail. The gold was transported under the strictest security and offloaded at Southampton into special trains that had come down from London.

Transvaal Castle

Sailing on the great liners! Geoff Edwards, who sailed for five years as a cabin steward aboard Union-Castle Line's *Transvaal Castle*, noted:

You made me realize [with your lectures] I was part of a golden, vanished age. We were on the UK–South Africa mail run, the express service. We carried some very interesting passengers – and some very rich ones as well. They were almost always well mannered, sometimes very kind and even friendly, but almost always very frugal – they rarely gave out decent tips. They felt that service, even very good and attentive service, was part of the fare. On this current trip [2015] aboard the *Queen Mary 2*, we are in the Princess Grill. We won't dream about not tipping!

Great Bygone British Passenger Ships 87

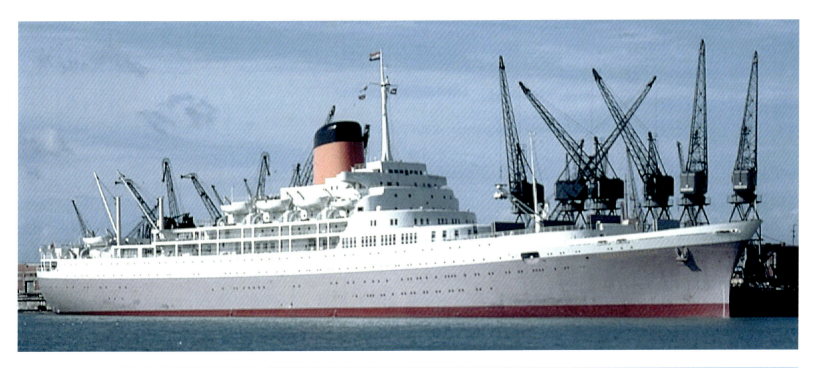

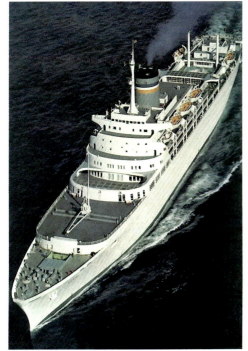

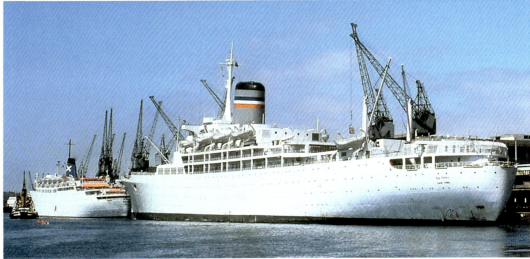

CLOCKWISE FROM TOP: Completed in late 1961, the *Transvaal Castle* was the last of the Union-Castle liners. (Mick Lindsay collection); In 1966, the *Transvaal Castle* was transferred to the Safmarine Lines and renamed *S.A. Vaal*. (Author's collection); In 1969, the ship changed from British to South African registry. (Union-Castle Line collection)

Durban Castle, *Warwick Castle*, *Rhodesia Castle*, *Kenya Castle* and *Braemar Castle*

A number of pre-war ships were used on Union-Castle's secondary passenger service that went completely around continental Africa. In 1958, five liners were used, allowing for fortnightly sailings. The 1938–39-built *Durban Castle* and *Warwick Castle* were joined in 1951–52 by a new trio of 552 all-one-class ships, the *Rhodesia Castle*, *Kenya Castle* and *Braemar Castle*. These ships had intensive, sixty-five-day itineraries: London, Rotterdam, Las Palmas, Ascension, St Helena, Walvis Bay, Cape Town, Port Elizabeth, Durban, Lourenço Marques (modern Maputo), Beira, Dar es Salaam, Zanzibar, Tanga, Mombasa, Aden, Suez, Port Said, Genoa, Marseilles, Gibraltar and then to London. The itineraries were reversed on each sailing.

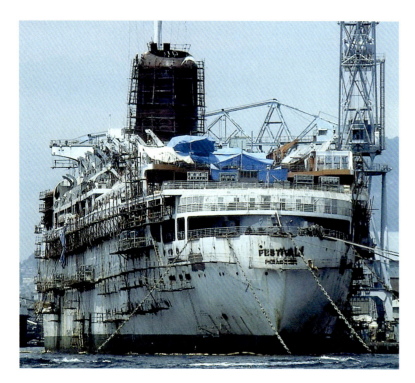

In 1977, the *S.A. Vaal* was sold to Carnival Cruise Lines and sent to a Kobe shipyard in Japan, where she was rebuilt as the *Festivale*. (Author's collection)

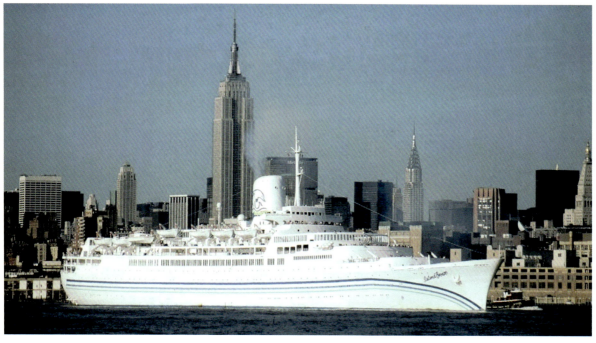

One of the last-surviving Union-Castle liners, the *S.A. Vaal* went on to sail as the *Festivale*, *Island Breeze* (seen here departing from New York) and finally *Big Red Boat III*. (Captain James McNamara collection)

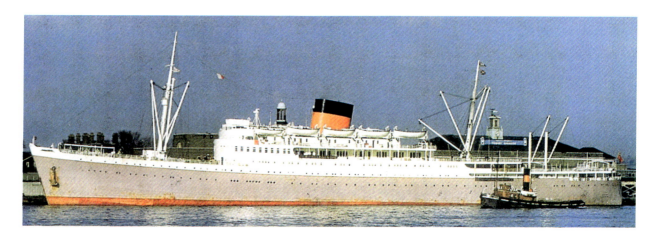

The *Braemar Castle* and her two sisters were one-class and created purposely for East African and then round Africa service. (David Williams collection)

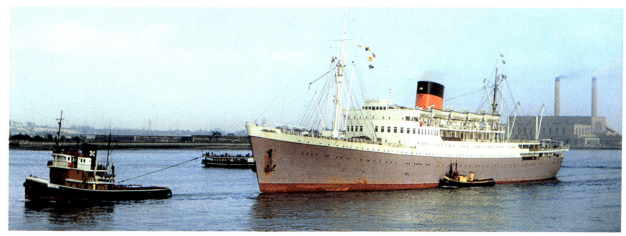

The *Rhodesia Castle* and her two sisters, completed in 1951–52, each carried approximately 550 passengers. (David Williams collection)

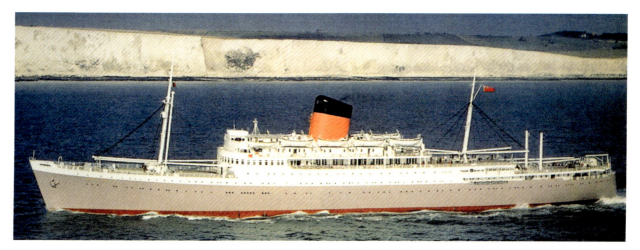

The *Kenya Castle* and her sisters were refitted and modernised in 1960–61, including the fitting of domed tops to their funnels. (Luis Miguel Correia collection)

RIGHT: Added in 1950, the all-one-class *Bloemfontein Castle* was purposely built for a projected migrant trade to East Africa. She is shown in her later career, after 1959, as the Greek liner *Patris*. (Tim Noble collection)

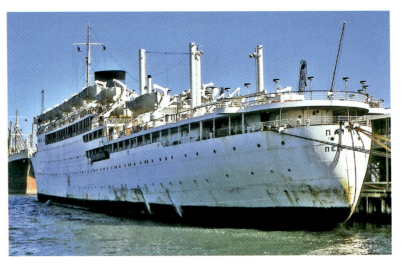

Bloemfontein Castle

The all-one-class, 727-berths *Bloemfontein Castle* plied an independent service: London to Lourenço Marques and Beira via Walvis Bay, Cape Town, Port Elizabeth, East London and Durban.

Reina Del Mar

The *Reina Del Mar* was Union Castle's only cruise ship and was in service until 1975.

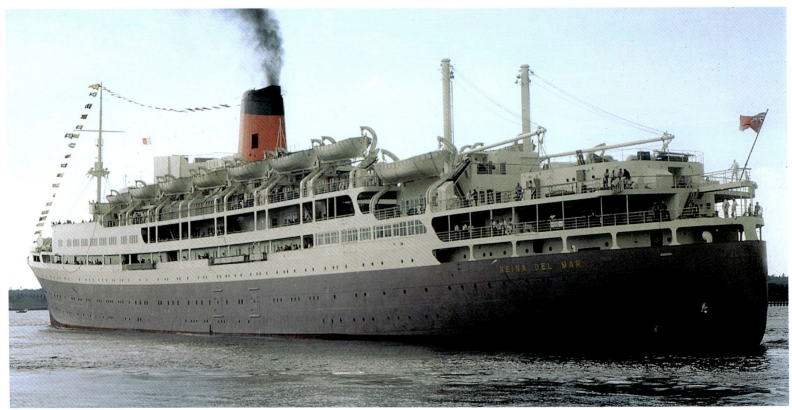

The *Reina del Mar* was rebuilt as a cruise ship in 1964 and managed by Union-Castle for cruises from Southampton and Cape Town. Union-Castle purchased the ship outright in 1973, but two years later it was sold again to Taiwanese breakers. (Mick Lindsay collection)

PART II

Great Passenger Ships Beyond …

More Modern-Day British Cruising

In the previous pages of this book, we have seen, with deep maritime nostalgia, members of the great British passenger ship fleet of the 1950s and '60s. Not only the ships themselves, but many of the shipowners are now long gone (with the obvious exception of names like Cunard and P&O). It is, indeed, a wonderful collection of ships, shipping lines and diverse services.

But by no means has British passenger shipping ended. It has, beginning in the sixties, simply transitioned to the age of cruising – voyages of fun and pleasure, and where the destination is no longer quite as important. The ships themselves have become the destination – 'floating resorts' with amenities ranging from huge showrooms to specialty restaurants, and from casinos to on-board gin distilleries. In fact, Britain was (in 2022) the third-largest cruise country anywhere; only the United States and Germany were larger. More British travellers are going to sea than ever before. And by 2022, the 184,000-ton sister ships *Iona* and *Arvia*, both of P&O Cruises, had put to sea, mostly on one- and two-week cruises. Costing nearly $1 billion each and carrying as many as 5,200 passengers, they are by far the largest British-owned passenger ships of all time. Within their towering, all-white configurations, they are the proud successors of such earlier liners as the *Orsova*, *Oriana* and *Canberra*.

In the following pages, we look at the evolution of British cruise ships, from the 1960s to the present. Undoubtedly – and including Cunard's fourth Queen, *Queen Anne* – there is more to come!

Sovereign Cruises

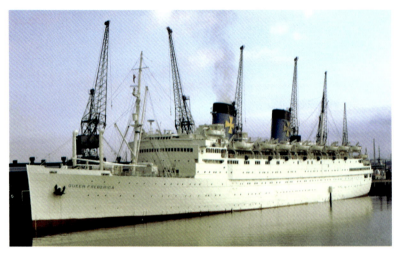

Some early cruising ventures, from UK ports as well as part of 'fly 'n' sail' packages, included Sovereign Cruises. In the early 1970s, they used the chartered Greek liner *Queen Frederica*. A seven-night cruise from Palma on Majorca, with flights to and from Gatwick included, was priced from £49. (Mick Lindsay collection)

CTC Lines

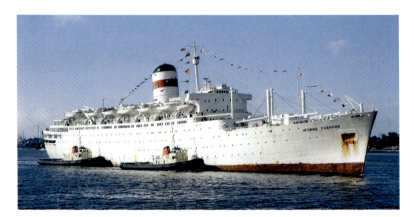

A long-popular British cruise operator was the CTC Lines, which chartered Soviet passenger ships including the *Leonid Sobinov*, formerly Cunard's *Saxonia* and later *Carmania*. (Mick Lindsay collection)

Cunard Line

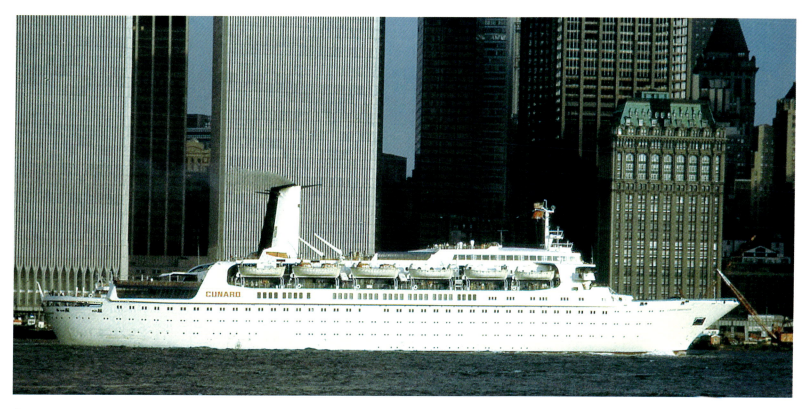

Cunard ventured more deeply into full-time cruising with the 806-passenger sister ships *Cunard Adventurer* and *Cunard Ambassador* (seen passing lower Manhattan) in 1971–72. (Author's collection)

Along with traditional itineraries, such as to Bermuda and the Caribbean, Cunard occasionally ran special cruises – such as several trips in 1973 along the upper Hudson River on board the *Cunard Ambassador*. The 14,100-ton ship is seen about to pass under the Bear Mountain Bridge. (Author's collection)

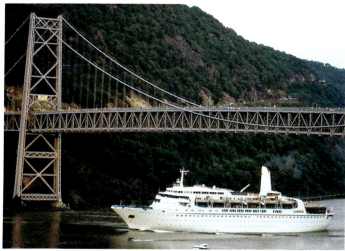

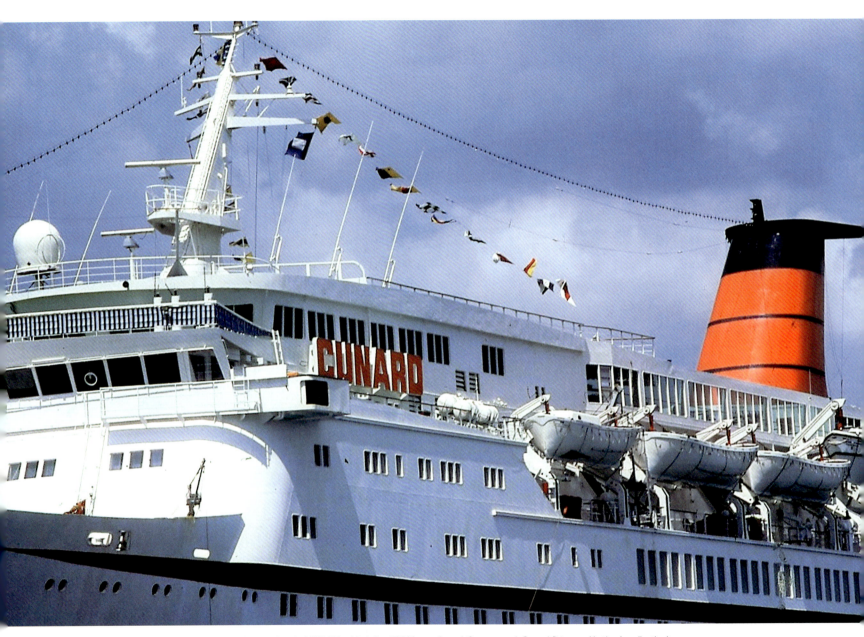

Cunard wanted larger (if only slightly) cruise ships and so, in 1976–77, added the 17,500-ton *Cunard Countess* and *Cunard Princess*. (Author's collection)

Great Passenger Ships Beyond ... 95

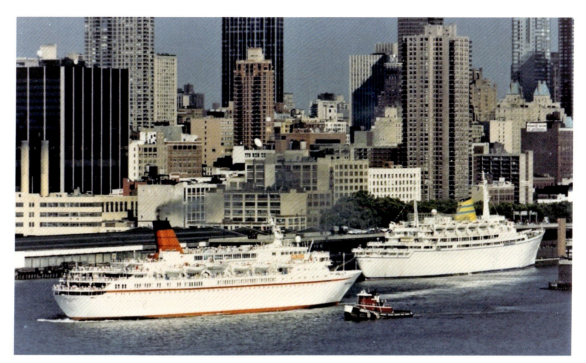

The *Cunard Princess* was used for a time on the popular seven-day New York–Bermuda cruise run. The *Vasco da Gama* is seen on the right. (Author's collection)

In 1983, Cunard acquired the impeccably reputed Norwegian America Cruises and their two splendid liners, the *Sagafjord* and *Vistafjord*. The former is seen departing from San Francisco in June 1984. (Author's collection)

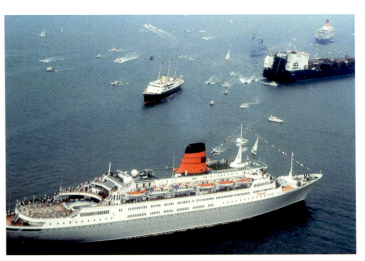
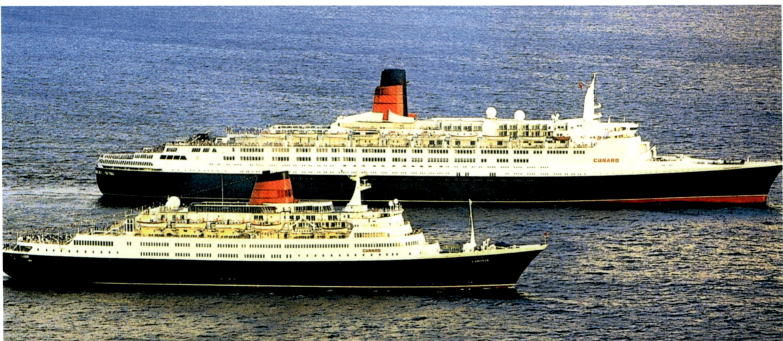

CLOCKWISE FROM TOP LEFT: Under Cunard, the *Vistafjord* often made cruises departing from Hamburg and so developed a strong German following. (Cunard Line collection); Cunard celebrated its 150th anniversary in July 1990 and a rendezvous was arranged off Spithead that included the *Vistafjord*, *QE2* and the Royal Yacht *Britannia*, which was carrying HM Queen Elizabeth II and Prince Philip. (Cunard Line collection); By 1998, Cunard was down to two liners, the *QE2* and the *Vistafjord*, but fortunately was soon purchased by Miami-headquartered Carnival Corporation (for some $600 million) and future expansion began. (Cunard Line collection)

Great Passenger Ships Beyond ... 97

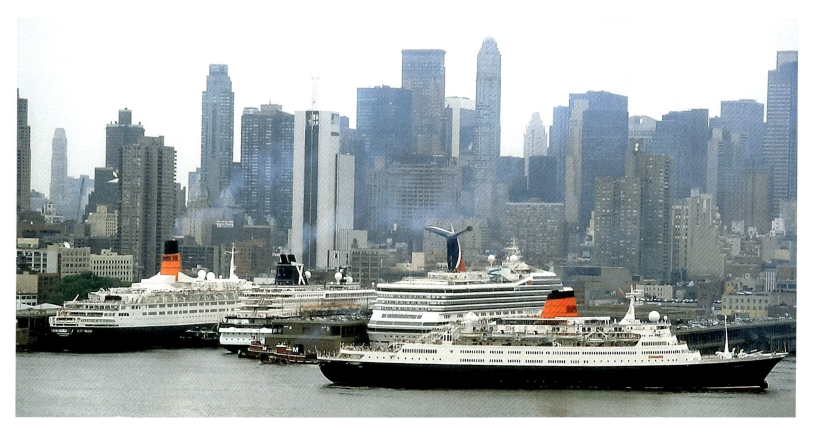

Cunard's illustrious heritage and their famous ships became important selling points, and they renamed the *Vistafjord* to *Caronia*. Seen here departing from New York in August 2001, the *QE2*, *Horizon* and *Carnival Destiny* are behind. (ALF collection)

For a short time, Cunard joined with Crown Cruise Lines and Crown's ships, such as the *Crown Dynasty* and *Crown Jewel*, were marketed as Cunarders. Their funnels were purposely repainted in Cunard colours. (Author's collection)

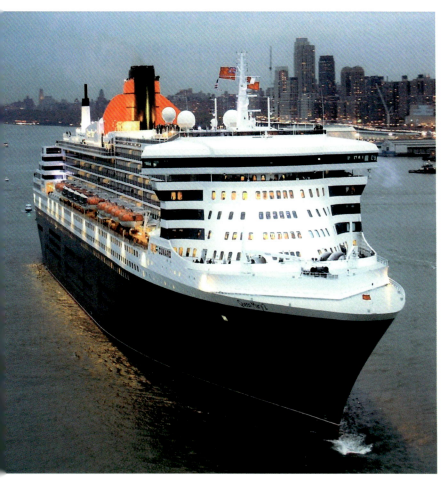
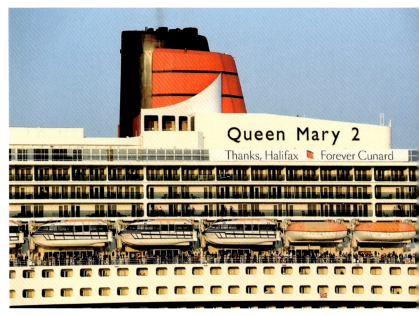
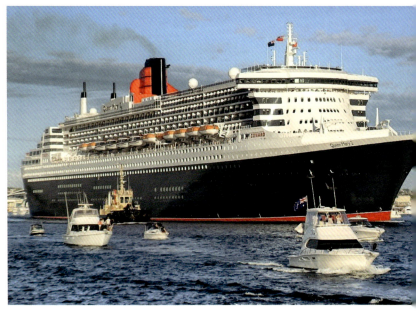

CLOCKWISE FROM ABOVE: In March 2000, Cunard officially announced it would build a 150,000-ton super liner for the continuation of transatlantic crossings, interspersed with cruises. Although there were rumours that the ship might be called *Mauretania*, it would be named *Queen Mary 2*. (Cunard Line collection); The $800 million ship would be the largest ocean liner yet. (Author's collection); Constructed at St-Nazaire in France, the ship would be 1,132ft in length, making it the longest liner ever built. (ALF collection)

Great Passenger Ships Beyond ... 99

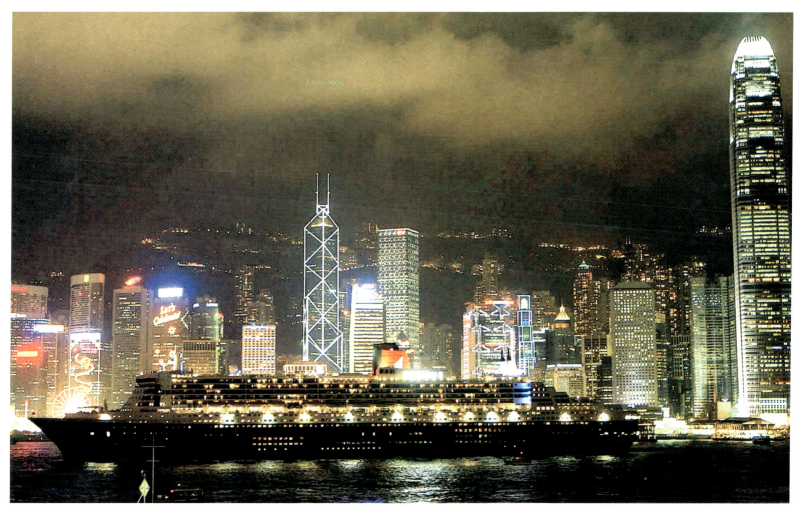

Designed to carry some 2,600 passengers in spacious quarters, *Queen Mary 2*'s designs called for bars and lounges, the largest library ever to go to sea, grill rooms and a specialty restaurant, shopping arcade, a large spa and showroom and the novelty of a planetarium. Seen here at Hong Kong, her varied itineraries would include a long, three-month winter cruise. (Cunard Line collection)

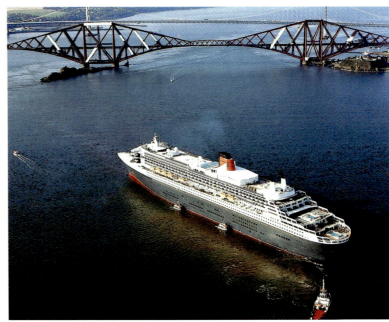
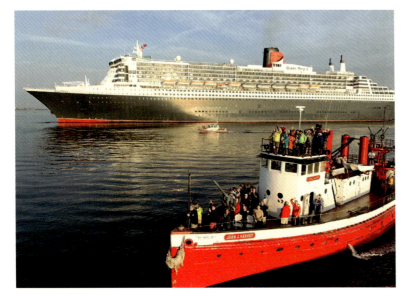

CLOCKWISE FROM TOP LEFT: Cunard's long history in shipping was shown in the decor while itineraries occasionally included visits to Liverpool, the company's 'ancestral home'. (Cunard Line collection); The *Queen Mary 2*'s travels have also included visits to places like Edinburgh. (Cunard Line collection); The Cunard flagship has developed a loyal following, especially for the seven-day crossings between Southampton and New York. (Cunard Line collection)

Great Passenger Ships Beyond ... 101

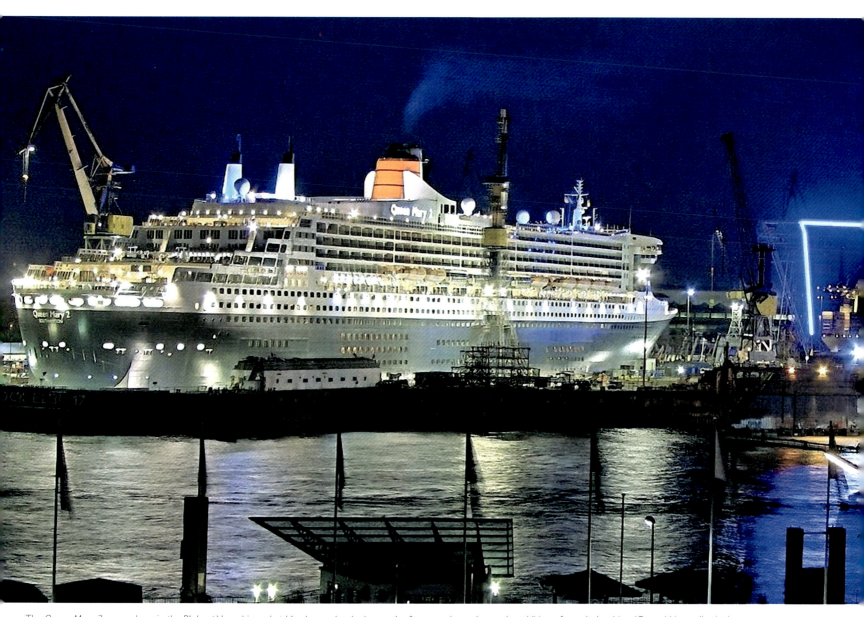

The *Queen Mary 2* – seen here in the Blohm+Voss shipyard at Hamburg – has had several refits, upgrades and even the addition of top-deck cabins. (Cunard Line collection)

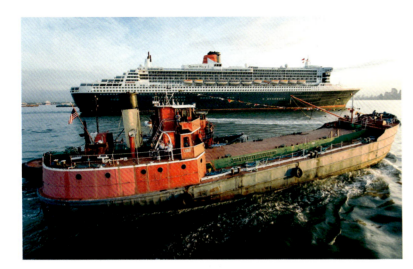
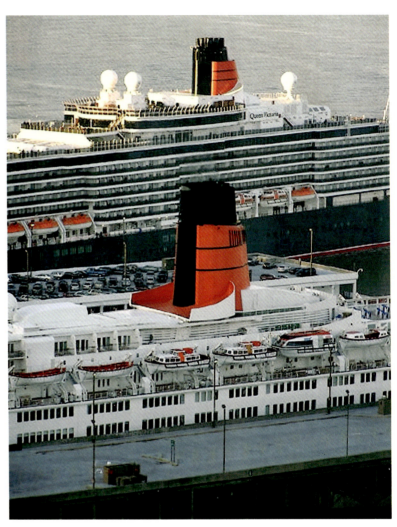
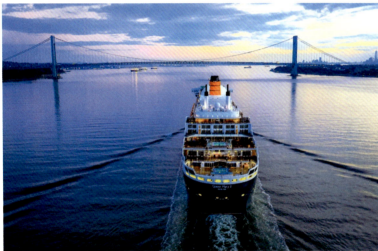

CLOCKWISE FROM TOP LEFT: In modern-day cruise fashion, the *Queen Mary 2* moves on. She usually remains in a port for eight to ten hours. (Cunard Line collection); The 92,000-ton, 2,400-passenger *Queen Victoria* was added to the Cunard fleet in 2006. She is seen here arriving at New York for the first time, with the *QE2* in the foreground. (Cunard Line collection); The great highlights of a crossing on the *Queen Mary 2* are the arrivals and departures in New York Harbor. (Cunard Line collection)

Great Passenger Ships Beyond ... 103

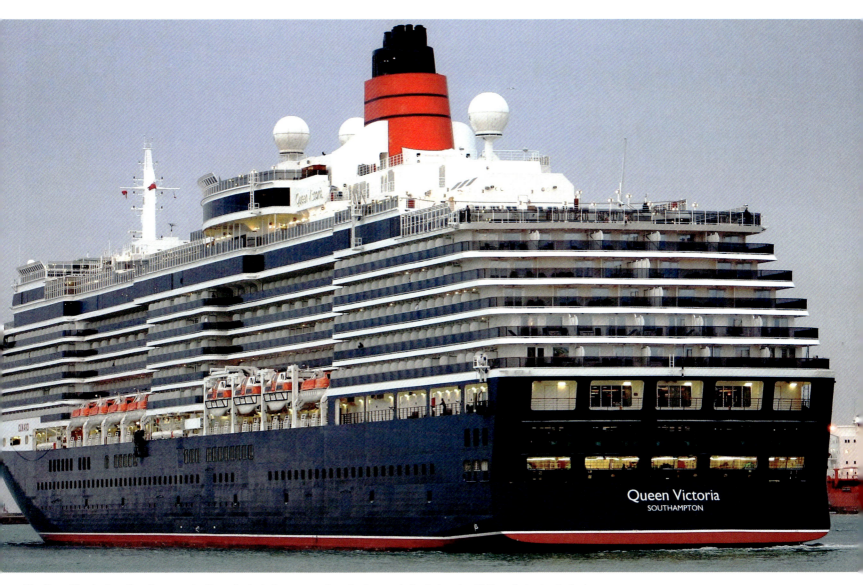

The *Queen Victoria* also offers diverse cruise itineraries, including voyages along the Amazon in South America. (Philippe Brebant collection)

CLOCKWISE FROM LEFT: Cunard markets the 'British quality and tone' of its sailings. (Cunard Line collection); In January 2011, the company was celebrated with a 'Cunard Day' at New York. (Cunard Line collection); In May 2015, Cunard celebrated its 175th anniversary with a special rendezvous of its three liners – *Queen Elizabeth* (top), *Queen Mary 2* (centre) and *Queen Victoria* (bottom) – at Liverpool. Over a million spectators lined both sides of the River Mersey to witness the event. (Cunard Line collection)

OPPOSITE: Expanding its itineraries to places like Japan, the Falkland and Aleutian islands, and Madagascar, the *Queen Elizabeth* has also made seasonal cruises to Alaska. (Cunard Line collection)

106 British Passenger Liners in Colour

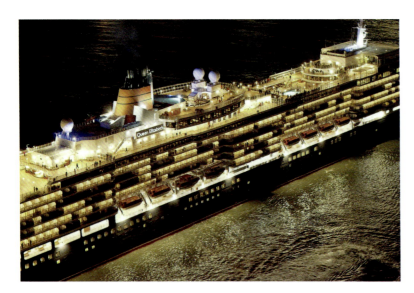

OPPOSITE: Cunard has organised numerous events that often include a rendezvous of the three Queens. (Cunard Line collection)

LEFT: The *Queen Elizabeth*, a near-sister to the *Queen Victoria*, was added in 2010. (Cunard Line collection)

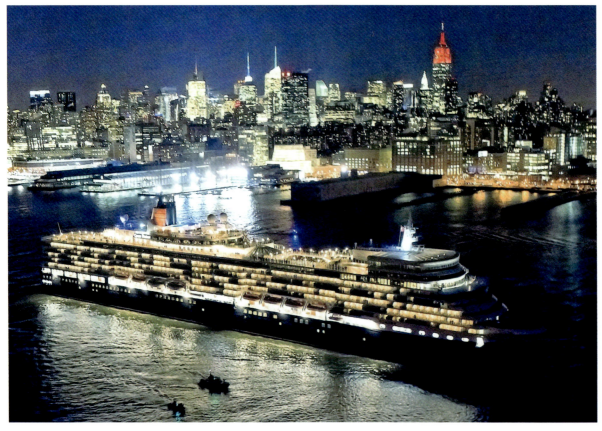

Seen during the Cunard celebrations in New York in January 2011, the *Queen Elizabeth* was in third position when the three Cunard liners sailed together in gleaming procession. (Cunard Line collection)

Great Passenger Ships Beyond ... 107

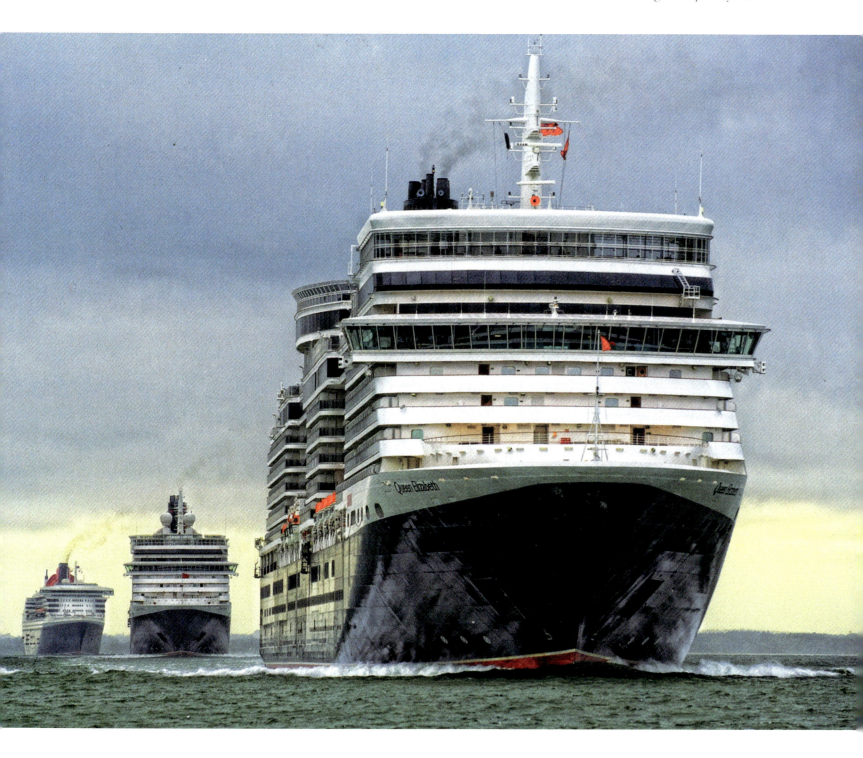

108　British Passenger Liners in Colour

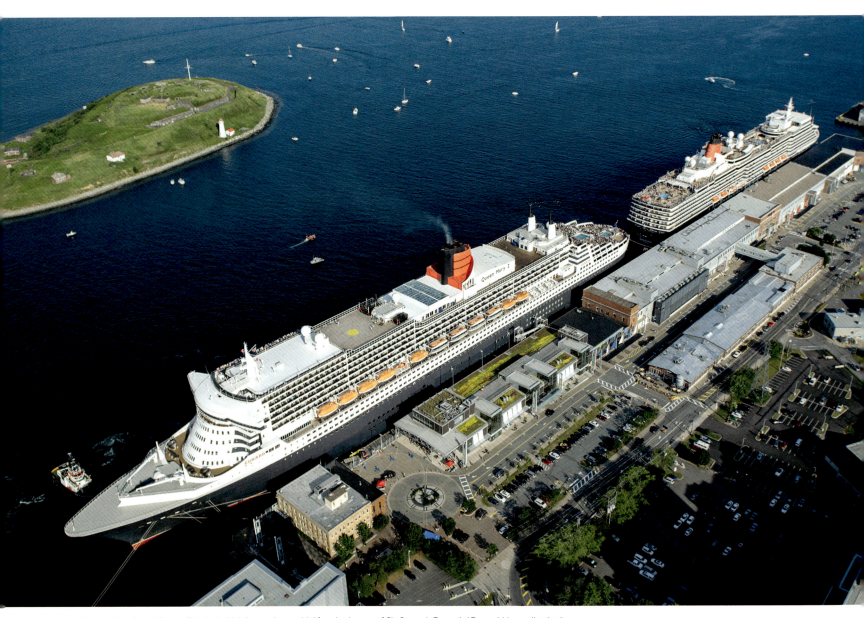

The *Queen Mary 2* and *Queen Elizabeth* (right) together at Halifax, the home of Sir Samuel Cunard. (Cunard Line collection)

Great Passenger Ships Beyond ... 109

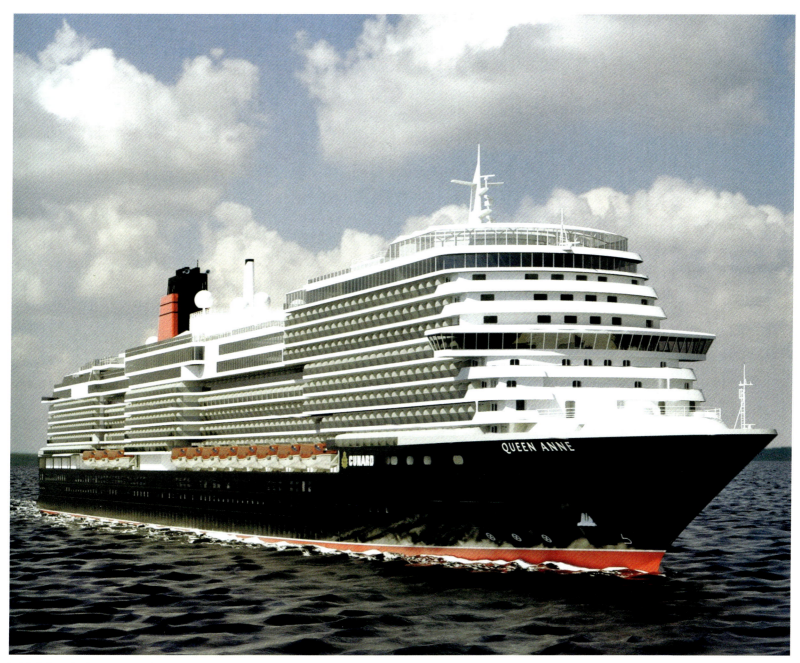

In 2024, Cunard will add a fourth Queen, the 100,000-ton, 2,900-berth *Queen Anne*. (Cunard Line collection)

P&O Cruises

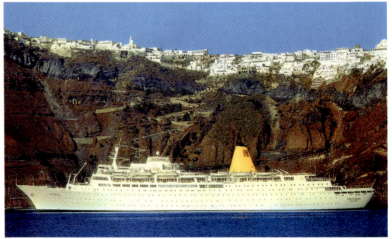

CLOCKWISE FROM TOP LEFT: By 1972, P&O decided to venture further into cruising with its first full-time cruise ship, the 17,000-ton, 900-passenger *Spirit of London*. However, the ship was soon transferred over to P&O's Princess Cruises division for North American sailings as the *Sun Princess*. (P&O collection); In the late 1970s, P&O wanted to reinforce its Australian cruise programme with a more 'up-market' ship and so bought the deluxe *Kungsholm*. Carrying only 750 passengers, the 26,678-ton ship – which was renamed *Sea Princess* – offered a club-like on-board atmosphere. (Luis Miguel Correia collection); The *Sea Princess* was later moved to UK cruising, from Southampton, and offered mostly two-week voyages to the Mediterranean, Scandinavia and the Atlantic isles. In winter, the ship also offered a long cruise around the world. (P&O collection); In 1995, P&O added the largest British-flag liner yet for UK cruising. Built in Germany, the 69,153-ton *Oriana* is seen here passing the earlier *Canberra*. (Author's collection)

Great Passenger Ships Beyond ... 111

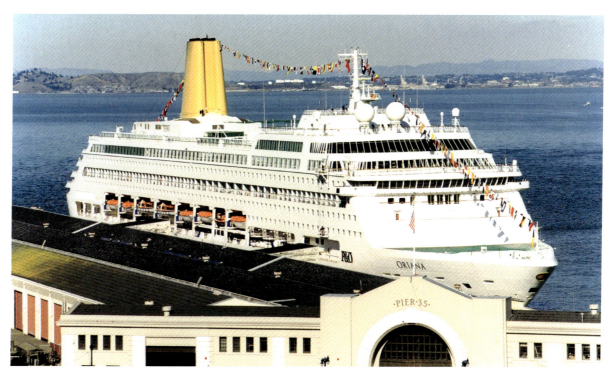

The *Oriana* – seen in this view at San Francisco – could carry a maximum of 1,975 passengers. (Marvin Jensen collection)

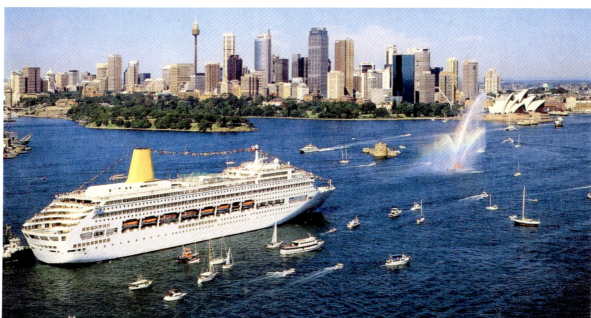

During a long, winter world cruise, the 850ft-long *Oriana* arrives at Sydney for the first time. (P&O Cruises collection)

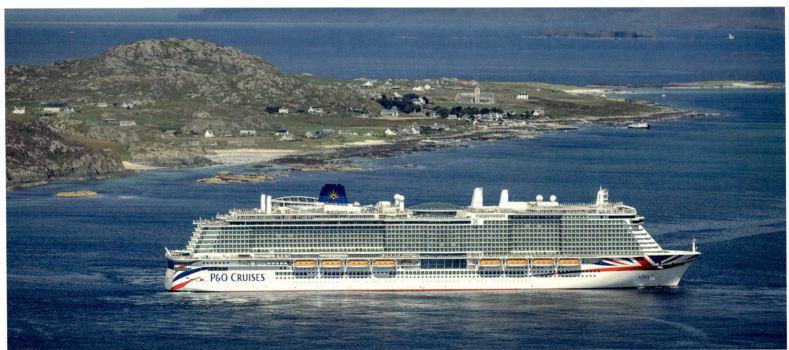

CLOCKWISE FROM TOP LEFT: The British cruise industry continued to expand and the success of the *Oriana* led to a slightly bigger version, the 76,152grt *Aurora*, joining her in 2000. (Author's collection); For P&O's 175th anniversary at Southampton in July 2012, the company's seven cruise ships sailed in a late-afternoon formation. (P&O Cruises collection); P&O Cruises was spun off as an independent company in 2000 and three years later was merged into the Carnival UK Group. In 2021, the company added the biggest British ocean liner yet, the 184,000-ton, 5,200-passenger *Iona*. (P&O Cruises collection)

Princess Cruises

Princess Cruises, a P&O subsidiary, began with North American cruising in the 1960s. But, in a great stroke of marketing genius and good fortune, the company permitted the television series *The Love Boat* to be filmed on board their *Sun Princess* and then the *Pacific Princess* (seen here at Sydney). The resulting publicity for the cruise business was extraordinary – 40 million Americans watched the weekly series. (Author's collection)

The *Sun Princess*, the former *Spirit of London*, is seen at St Thomas in November 1983. (Author's collection)

St Helena Shipping Company

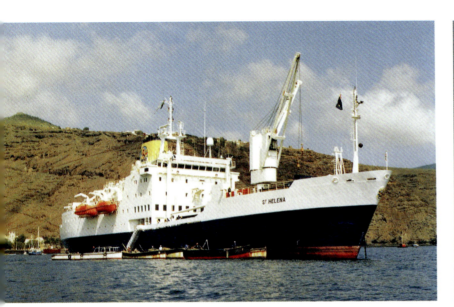

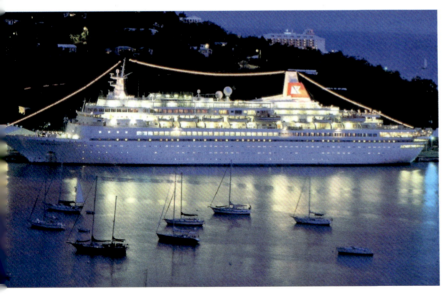

Fred. Olsen Lines

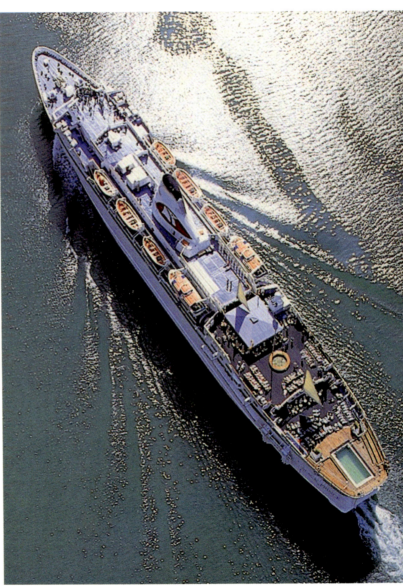

CLOCKWISE FROM TOP LEFT: In the late 1970s, the Curnow Shipping Company joined the government of the island colony of St Helena to form the St Helena Shipping Company. Their purpose was to take over the UK–South Africa run (with stops at St Helena) that had been abandoned by the Union-Castle Line in 1977. Their first ship was the eighty-eight-passenger *St Helena*, followed by a new build in 1990, also named *St Helena*, that carried up to 128 passengers. (St Helena Shipping Company collection); While actually Norwegian, the Fred. Olsen Line became a British cruising favourite in the 1960s, with winter voyages from London to the Canaries and Madeira. They began with smaller ships such as the 450-passenger *Black Prince*. (Fred. Olsen Line collection); The luxurious *Royal Viking Star* later joined Fred. Olsen to become the *Black Watch*, shown here at St Thomas. (Fred. Olsen Line collection)

Great Passenger Ships Beyond ... 115

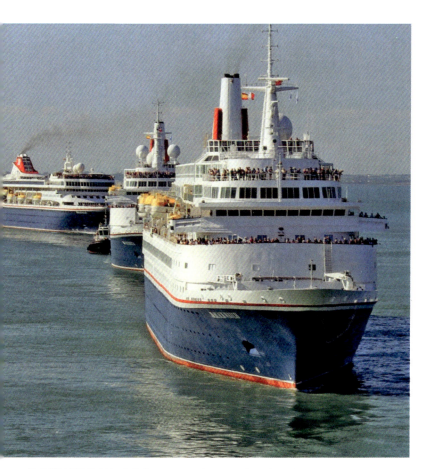

CLOCKWISE FROM ABOVE: As a marketing stunt, Fred. Olsen had an annual rendezvous of its fleet. Here we see the *Boudicca*, *Black Watch* and *Braemar*. (Fred. Olsen Line collection); Fred. Olsen developed a large and loyal following, and offered voyages from 2 to 150 days. The *Black Watch* is seen here at Honfleur in a photo dated May 2010. (Philippe Brebant collection); Completed in 1993, the *Braemar* had been the *Crown Dynasty*, *Crown Majesty* and *Norwegian Majesty* before joining Fred. Olsen in 2001. (Fred. Olsen Line collection)

Saga Cruises

Discovery Cruises

Saga Holidays created Saga Cruises in 1997 with the *Saga Rose*, ex-*Sagafjord*, and later with the *Saga Ruby*, ex-*Vistafjord*. (Saga Cruises collection)

UK-based Discovery Cruises offered cruises on the 650-passenger *Discovery*, the former *Island Venture*, which would be renamed *Island Princess*. (Discovery Cruises collection)

Saga expanded its itineraries and its cruising fleet, including the addition of the *Saga Pearl II*. Built in 1981, the ship had been the German *Astor*, *Arkona* and then *Astoria* before becoming the *Saga Pearl II*, then *Quest for Adventure* and finally reverting to *Saga Pearl II*. (Philippe Brebant collection)

Cruise and Maritime Voyages

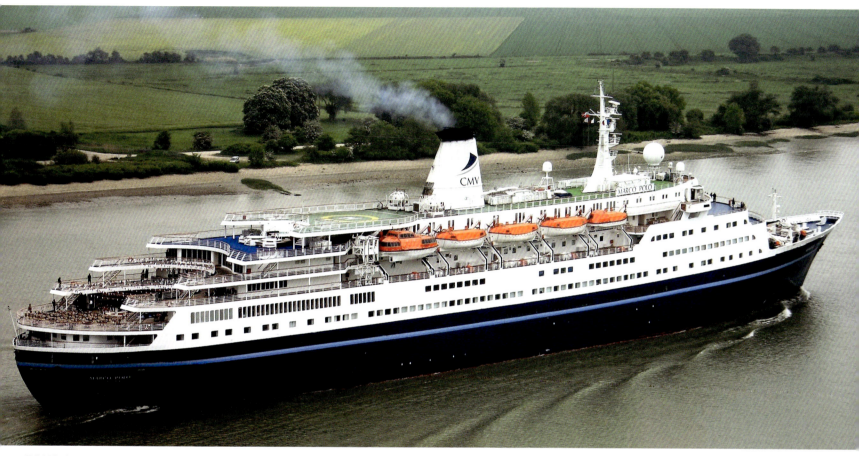

CMV (Cruise & Maritime Voyages) was created in 2009 and developed a loyal following with their fleet of second-hand cruise ships, including the 800-passenger *Marco Polo*, built in 1965 as the Soviet *Alexandr Pushkin*. The 22,000-ton ship is seen here at Tancarville in France in April 2011. CMV closed in 2021 and the 56-year-old *Marco Polo* was sold for scrap. (Philippe Brebant collection)

OVERLEAF: As the likes of historic Cunard and P&O add new liners, the British cruise industry continues to expand and ranks as the third-largest worldwide. Thus, the tradition of great British ocean liners – from the era of the original *Queen Mary* and *Queen Elizabeth*, the *Canberra* and *Oriana*, the *Windsor Castle* and those smaller ships such as the *Uganda*, *Hubert* and *Aureol* – will continue. In this last view, we see the *Queen Mary 2* and *Queen Elizabeth* together at Halifax in July 2019. (Cunard Line collection)

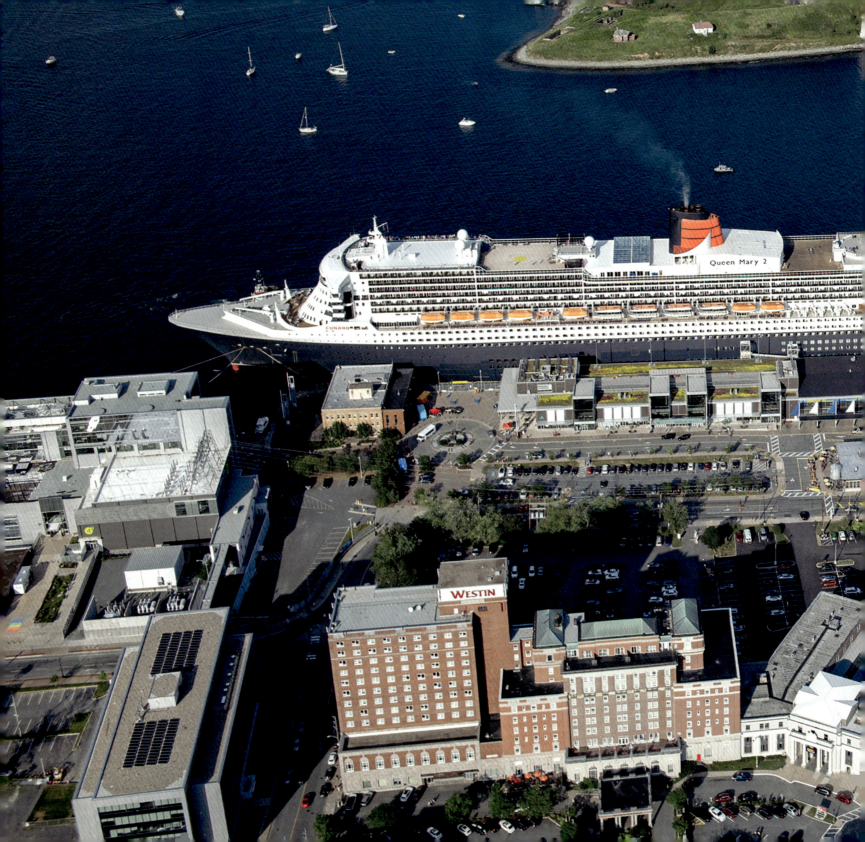

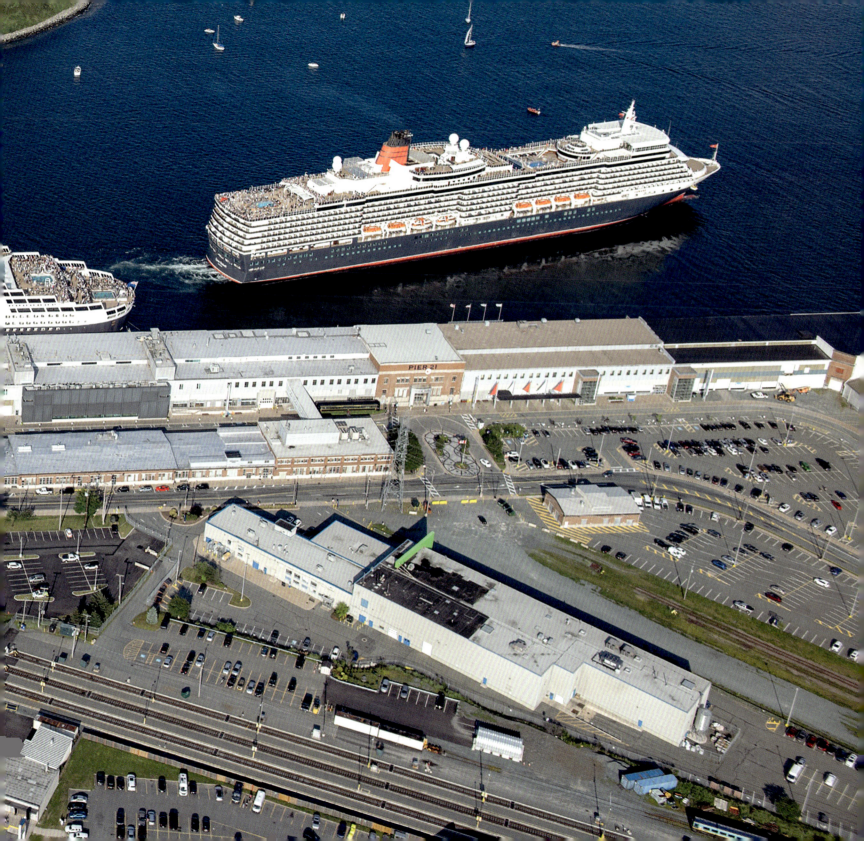

Bibliography

Dunn, Laurence, *Passenger Liners* (Southampton: Adlard Coles Ltd, 1961).

Fiebig, Raoul; Heine, Frank; and Lose, Frank, *The Great Passenger Ships of the World* (Hamburg: Koehlers Publishing Co., 2015).

Kludas, Arnold, *Great Passenger Ships of the World* (Vols 1–5) (Wellingborough: Patrick Stephens Ltd, 1984, 1992).

Kludas, Arnold; Heine, Frank; and Lose, Frank, *The Great Passenger Ships of the World* (Hamburg: Koehlers Publishing Co., 2002, 2006).

Mayes, William, *Cruise Ships* (5th edn, Windsor: Overview Press Ltd, 2014).

Miller, William H., *Pictorial Encyclopedia of Ocean Liners, 1860–1994* (Mineola, New York: Dover Publications Inc., 1995).

Miller, William H., *Picture History of British Ocean Liners* (Mineola, New York: Dover Publications Inc., 2001).

Official Steamship Guide (New York City: Transportation Guides Inc., 1953–63).